*A lake is the landscape's most beautiful and expressive feature.
It is the earth's eye, looking into which the beholder
measures the depth of his own nature.*

Henry David Thoreau, Walden

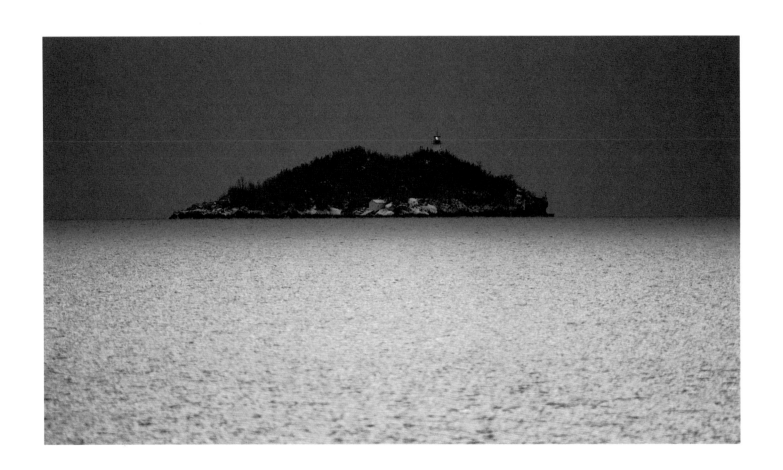

Trowbridge Island Lighthouse, Ontario, Canada.

# DISTANT SHORES

## PHOTOGRAPHS FROM LAKE SUPERIOR AND LAKE MICHIGAN

PHOTOGRAPHY BY RICHARD OLSENIUS
TEXT BY RICHARD AND CHRISTINE OLSENIUS

BLUESTEM PRODUCTIONS • TWO HARBORS, MINNESOTA

Published by Bluestem Productions, Box 285, Two Harbors, Minnesota 55616

Printed in the United States of America at Watt/Peterson Inc., 15020 27th Avenue North, Plymouth, Minnesota 55447

Library of Congress Catalog Card Number: 90-083206

ISBN: 0-9609064-5-2

First Printing. 1990
10 9 8 7 6 5 4 3 2 1

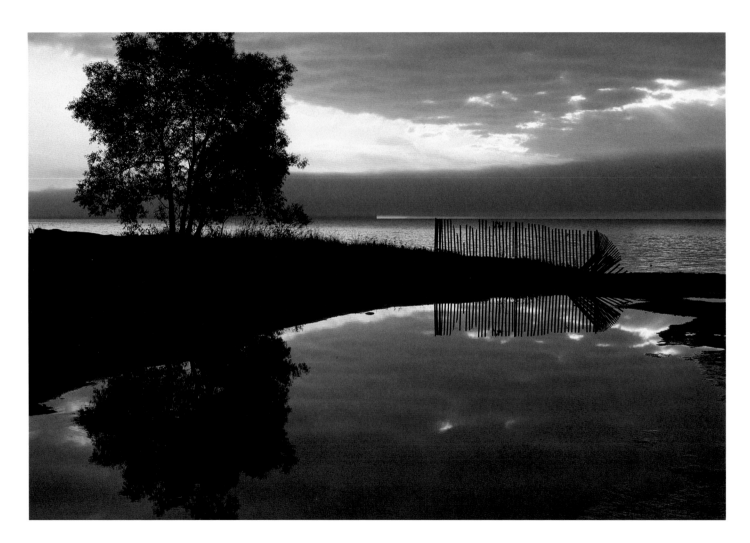

Overlooking Apostle Islands National Lakeshore, Bayfield, Wisconsin.

*To the spirit and preservation of these Great Lakes*
*and to all those who have*
*traveled their shores.*

# INTRODUCTION

As a child, it's hard to know what I gained from traveling. So much slipped past me, lost in the backroads of a child's mind.

I remember my father coming home with AAA TripTik books to plan our summer vacation. I knew it wouldn't be long before he'd strap on the luggage carrier, get oil for the car and wave goodbye to the neighbors. It seemed we were the only ones who ever left the old neighborhood because my friends were usually standing in the same place when we returned.

I remember standing behind my father in the backseat for hours on end, looking over his shoulder down endless highways. I remember hot days east of Minnesota, the orange roofs of Howard Johnsons, the flapping of canvas from the luggage carrier and the horse ride on Mackinac Island.

I remember sitting at my grandma's farm south of Lake Erie, where she told me, "Look carefully, cause on a clear day you can see one of the Great Lakes." And sure enough, there would be a break in the summer haze and I'd see this blue band of water that seemed to go on forever.

It was sometime after my junior year in high school that a family friend told me about this lake called Superior. He said, "If you ever want to really see something, go to Superior." I distinctly remember him telling me about the old fishing village of Bayfield, and the small towns of Cornucopia and Herbster and the high dunes near Pictured Rocks National Lakeshore. He talked of the North Shore drive with this distant look in his eyes. I had never heard anyone talk about a place like that before.

That may have been the first time I developed a curiosity about someplace. Maybe it was because I

was now driving a car and this new freedom needed a place to go. Or was it tripped by a memory of that wide horizon on Lake Erie? I remember the urge I felt to explore this lake.

I had always viewed lakes as water contained by a shoreline, like a fence defines a field. So when the trees opened up and I got my first glimpse of Superior, there came upon me that sense of something truly awesome. This was something more than a passing attraction, like the vacations of my youth.

I couldn't have known then, as I stood before Superior as a young man, that the lake would become a dominant part of my personal and professional life for the next twenty-five years. First it was its sheer beauty. Then as a sailor, I was drawn to the adventure and wildness of the lake. My photo assignments introduced me to the people of Superior and the other Great Lakes, and they finally put the region in perspective for me. Their strength, endurance and determination reflected something I had always seen in the landscape.

Those special places of Lakes Superior, Michigan and the other Great Lakes will always be needed for the child and adult in us. No matter how wealthy or important one is, or how confused and stressed we become as daily life takes its toll, we all need a renewed sense of wonder and scale that these bodies of water provide.

Even after traveling thousands of miles along the Great Lakes, my first impressions of Lakes Superior, Michigan and Erie have barely faded. Unlike returning to your childhood home, where the streets seem smaller and the buildings shorter, these lakes still appear as magnificent as ever.

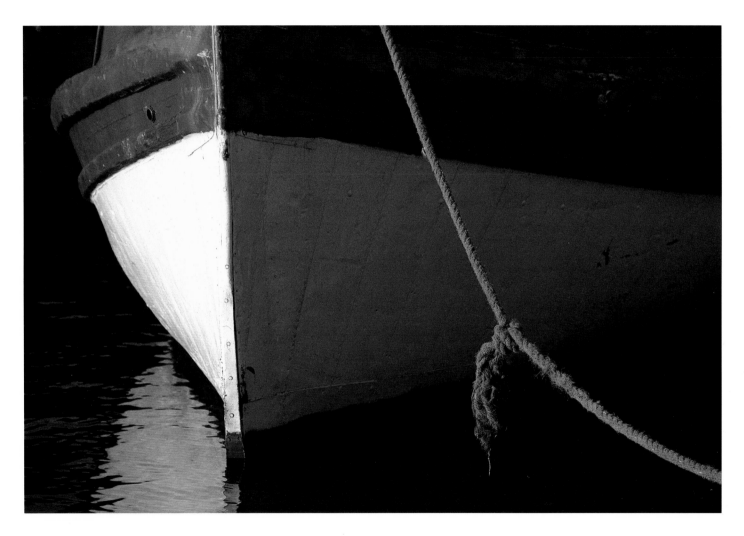

Fish Tug, Beaver Bay, Minnesota.

# THE LAKES

We are a part of our regional landscape. We are attracted to its features and the lifestyle they provide. We are shaped by its weather and bound by its history and traditions. Like any region, the Great Lakes have changed us every bit as much as we have changed them. It is important for us to understand that interconnection, to help us see their future as our future.

The Great Lakes live up to the grandeur their name suggests. The largest expanse of freshwater in the world, these lakes comprise one-fifth of the world's fresh surface water. They link eight states, two nations and provide an international highway for the resources of North America. They were as awe-inspiring when seen from the birch bark canoes of early voyageurs, as they were to the astronauts when viewed from space, and to all of us who have viewed them from the shore. Ocean-like in their appearance, these inland seas create their own weather system, keeping winters milder and summers cooler throughout the region.

The two westernmost lakes, Superior and Michigan, are closest to America's heartland, where their 4,000-mile shoreline defines a Midwest Coast. They provide the vital link between the resources of the farms and factories of the Midwest and the markets of the world, While different in personality and temperament, their economies have always been interdependent. Iron ore from Minnesota's Mesabi Range, the largest ore deposit in the world, fueled the steel mills of East Chicago and Gary, the backbone industry of the nation's economy.

There is a bond between these lakes as real as the physical features we can trace on a map. This interconnected system of water has linked people, industries, histories and economies in the heart of the North American continent. Our geography has shaped our collective perspective, our world view. We are drawn, like all societies, to the life-giving quality of these vast water resources, resources that have defined our past and will shape our future.

# LAKE SUPERIOR

Sunrise on Superior is a time of quiet beauty. Subtle shades of grey and mauve blend in the predawn light. Only after the sun has risen, do the colors separate water from sky, and then only on a clear day. On hazy or foggy days, water and sky provide a uniform canvas upon which constantly changing weather systems paint their color, texture and mood. Few places offer such a panorama of nature's energy. The ocean, certainly, and perhaps, the Great Plains of the West.

While forests surround and contain you, Lake Superior exposes and confronts you. It redefines all preconceptions of a lake. As you gaze across it, searching for the horizon, consider that 25 Lake Eries would fit into Superior.

From the very beginning the lake was superior. In size, in distance, in legends, danger and majesty, Lake Superior's reputation is well-deserved. By surface area, Superior is the largest lake in the world and the headwaters of the Great Lakes. With 10 percent of the world's surface freshwater supply, it is a resource of international significance.

The lake of superlatives has a coastline to match. The jagged Canadian North Shore is chiseled in sheer coastal cliffs and fjord-like bays, forged through a history of volcanic fire and glacial ice. Volcanic activity over a billion years ago fractured the continent in a **great** curve from eastern Kansas, through Lake Superior, south through Michigan's lower peninsula, almost as far as Kentucky. Along this rupture flowed molten lava forming some of the most scenic features of the lake; Palisade Head, Isle Royale and the Keweenaw Peninsula.

This volcanic activity formed the immense Canadian Shield, the ancient rock which forms the foundation of the North American continent. Superior lies embedded in this shield. Ten thousand years ago the glaciers carved and furrowed the final features and shoreline of the lake we see today. As they retreated, new life forms emerged, clinging tenuously to crevices of rock. Through endless cycles of life and death, the thin soil gave birth to lichens, caribou moss, harebells, pine and cedar. A fragile beauty for a fragile land.

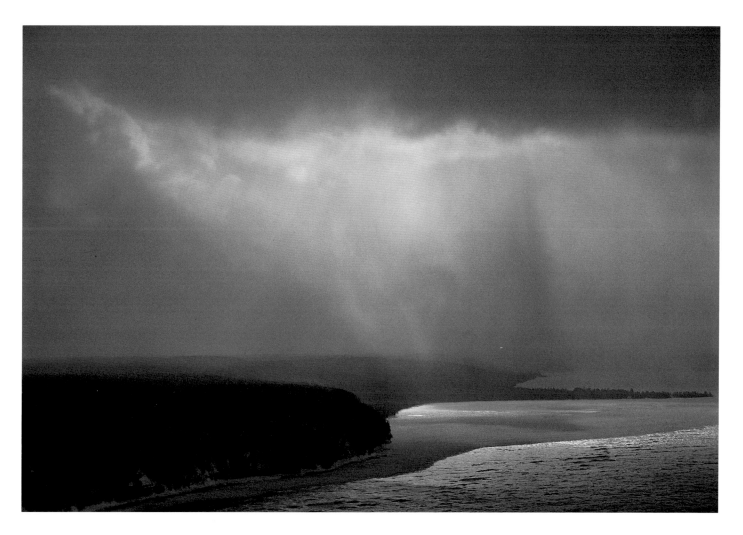

Lake Superior snow squall, Pictured Rocks National Lakeshore.

Isle Royale National park follows the contours of Minnesota's North Shore, with the cliffs and coves of its northwest coast mirroring the broad escarpment of the mainland. The island is an ecosystem all to itself, where moose and wolf carry on their ancient symbolic relationship and where human visitors are but a transient few.

Some islands off the Canadian North Shore have flora and fauna indigenous to the arctic. As proof of the remote landscape, woodland caribou can still be found on the Slate and Lake Nipigon Islands, remnants of herds once common in the region a hundred years ago.

In contrast to the wilderness of the North Shore, Superior's southern coast is a more gentle, but varied shoreline. Wisconsin's Apostle Islands have second growth forests of aspen, birch and pine and many are ringed with white sand beaches. Farther east are the multi-hued sandstone cliffs of Pictured Rocks National Lakeshore, sculpted by wind and water into endless formations and crowned by the softer wilderness of Grand Sable Dunes.

Fishermen from the village of Bayfield still ply their trade amid the increasing number of pleasure boats in the Apostle Islands. Quarries on Stockton, Basswood and Hermit Islands, which built the brownstone rowhouses of Chicago and New York, lie dormant in the forest undergrowth. Madeline Island, now a fashionable resort, was once the home of the Ojibway Indians and a key commercial center for the fur trading industry.

Michigan's Keweenaw Peninsula, jutting a curved finger into Lake Superior, remains a land untamed. Its hardwood forests provide a splendor of fall color along the Porcupine and Huron Mountains. Rich in copper deposits that formed in the clefts of ancient rock, this region was first mined by aboriginal cultures millennia ago. In the last century, it contained one of the most ethnically diverse populations of the Great Lakes, as successive generations of immigrants came to mine the copper. In spite of the long mining tradition, the land does not reflect the industrial dominance evident in the southern part of the state.

Sailing allowed me an enjoyable way to explore the secrets of Superior. I remember the silence on board the *Sheila Yeates*, a chartered sailboat, when we passed the islands along Canada's "inland passage." Here were places a native American from 150 years ago would still recognize today; places untouched by change since the last glaciers scoured the landscape. There is a remoteness along Superior's Canadian north shore that I have experienced in very few places. Islands with no trails speak to few human visitors. Even the wildlife is relatively unafraid, they have seen so few of us.

On the few islands that have been inhabited, only relics of their previous lives remained; empty lighthouses, deserted fishing camps and long-abandoned mining camps. They seemed superfluous to the landscape and so ephemeral, long reclaimed by an assortment of vegetation. Superior has a way of putting life in perspective.

It was sailing on the *Sheila Yeates* that I first met skipper Geoff Pope. "I can't imagine wanting to mow the lawn and not go sailing," he said to me, gazing across the Canadian shore. At 65 he had realized a lifelong dream of building a classic sailing vessel. His trips through the Great Lakes inspired a sense of adventure and fulfillment in those who chartered the 50-foot top sail ketch under his command.

Now at the age of 75, his restless curiosity seemed to give him boundless energy. He would watch each ripple of sail and sense a wind change with his nose. He knew each indentation of coastline, its history and geology. He had endless tales of maydays and shipwrecks - sailor's stories to share with crew in the evening kerosene light of the ship's saloon.

Now, he was preparing for a new adventure and everyone was to be a part of it. He wanted to sail the *Sheila Yeates* out the Great Lakes, across the Atlantic to Iceland, Scotland and England. When it came time for departure from Duluth in early summer of 1989, veterans of past charter trips were there to mark the send-off. Relay crews met the ship throughout the Great Lakes as she headed for the St. Lawrence Seaway. In St. Anthony, Newfoundland, the *Sheila Yeates* embarked for Reykjavik, Iceland. Nine days later, she was caught in pack ice off Cape Farewell, Greenland.

Damaged by ice, the vessel and crew were rescued by a Danish trawler. But the *Sheila Yeates* sank under tow in

gale force winds in the North Atlantic, July 17, 1989. In the fall of 1989, Geoff returned to Lake Superior to develop plans for another *Sheila Yeates*. "This isn't an ending, it's a beginning," he told me. The *Sheila Yeates* lives on in a shipyard in Duluth, with the support of past and future crews who believe in his dream. "Dreams don't die," Geoff explained, "They just take new forms."

His eyes were steel blue like the lake he had fished his whole life. When he rested his hand on the gunnel of the weathered fishing boat, it blended with the warped wood and peeling paint. Helmer Aakvik was a man defined by his landscape, and for me he personified Superior's North Shore.

Like so many others of the lake who had learned to live with its harsh and unpredictable ways, at 85, his face was molded by time and weather. He had a stubborn set to the mouth, a quiet determination in the eyes, and cheeks with rugged edges like the Sawtooth Range that rose beyond his home. He had come from Norway in his youth, looking for opportunity and adventure. After farming, logging, a series of odd jobs and just plain wandering, it seemed no place could hold him until he saw Superior. The lake finally claimed his affection and respect.

A quiet and unassuming hero, at 63 years of age he had kept a stormy November vigil in an ice-covered open boat amid 20-foot seas, looking for a young fisherman who had not returned from his nets. Twenty-seven hours later, Helmer returned home empty handed. The young fisherman was never found. Helmer's courageous action brought him fame and an outpouring of sentiment from people across the country. He always remembered that event, not for the fame he won but for the friend he lost. Even twenty-five years later when I met him, he would think of the young man when he looked across the water.

Sometimes they glide along the horizon like a ghostly apparition, bows slicing a course through the lake as they head for distant ports. The freighters are a physical reminder that this freshwater highway flows to the sea and international ports of call. You can hear the low-pitched hum of engines and sometimes feel their deep vibration as they pass offshore.

The ore boats look like floating ball fields with the bleachers and press box on the stern. Their smoke stacks wear the team emblem, reflecting owners like U.S. Steel, Inland Steel and Columbia, the passing lineup of Great Lake maritime history.

At night the freighters masquerade as cruise ships. Their myriad lights look like a festival at sea, reflecting an incongruous image of fun and romance.

It seems paradoxical to watch ocean-going vessels pass the forested coastline of Superior's north country, yet they are the lifeline that ties the resources of the region to the markets of the world.

They are a bellwether of seasonal change. The last one leaving Lake Superior signals the closing of the Soo Locks to ice and the onslaught of winter. The lake seems more silent and more lonely without them. Spring arrives with the opening of the locks, in the form of a freighter bound for Duluth. To the communities along the shore, the ships are a pulse of the region's vitality.

I met Clem Morrison at the Great Lakes Towing Company in the Duluth-Superior harbor several years ago. To say he was a man of few words, was an understatement. I spent several days on his tug as the shipping season began to peak in late summer. This was Clem's 50th year of tugging, his 35th as a captain.

In his half-century of tugging, he had seen Duluth evolve from a Midwestern town into an international seaport. He saw changes in the steel industry and new technology eliminating the need for his services. "The ships have gone from 350 feet to over 1,000 feet in length. Lakers have bow thrusters and stern thrusters now, they don't need us like they used to."

His pipe never wavered. Not once in bringing the tug along the stern of the 6-story freighter. Not once in edging the huge vessel through the labyrinth harbor. Not once in effortlessly docking the 30,000-ton ship to the pier.

If there was fear, surprise, concern or anger, it had never shown during the years he captained his tug. His face was implacable, his words few and far between. "You must have had some close calls in your 50 years of tugging?" "Yep," was his only reply.

# Lake Michigan

When the glaciers retreated from Lake Michigan 10,000 years ago, they left a gentle coastline of sandy beaches, rich marshland and fertile soil. Through the centuries, prevailing westerlies blew vast amounts of shale and sandstone soils into sand dunes hundreds of feet high that stretch from the Indiana border to the Straits of Mackinac - the largest accumulation of sand dunes on any body of freshwater in the world.

The landscape shrouds changes that have been at work for centuries. Over time, endlessly shifting sand has covered forests of white cedar, and then uncovered them years later. Such a "ghost forest" exists at Sleeping Bear Dunes National Lakeshore, a magical place where the marks of man are few in number and brief in duration.

The climb up the face of the dunes was an effort and once on top, it could have been the Sahara Desert minus the humidity. It was incredible, this sea of sand and grass. I walked for over an hour before the ghost forest appeared.

Some of the trees were standing and others were scattered around like a prehistoric burial ground. To see these trees confuses one's sense of time and scale. Once there was a forest. Then it was covered in sand. Now it has been uncovered by wind, only to be buried in sand again in some distant year. Nothing is permanent. I approached the trees carefully, wishing not to leave footprints, for even a short time.

I waited there an hour, sitting 200 feet above the lake watching the forces of wind, water and sunlight. On one side rain clouds crept along the lake's horizon and on the other side, the ghost forest looked like bleached bones in the late afternoon light. The light finally softened and a cool wind blew up from the lake. A chill came over me. There was something in the ghost forest that made me move on. It was mine to enjoy for awhile, but I did not belong there.

Andy is a third-generation fisherman. His port of Algoma, Wisconsin, on the western coast of Lake Michigan, was once home to 27 commercial boats. Now there are only two. As you look around

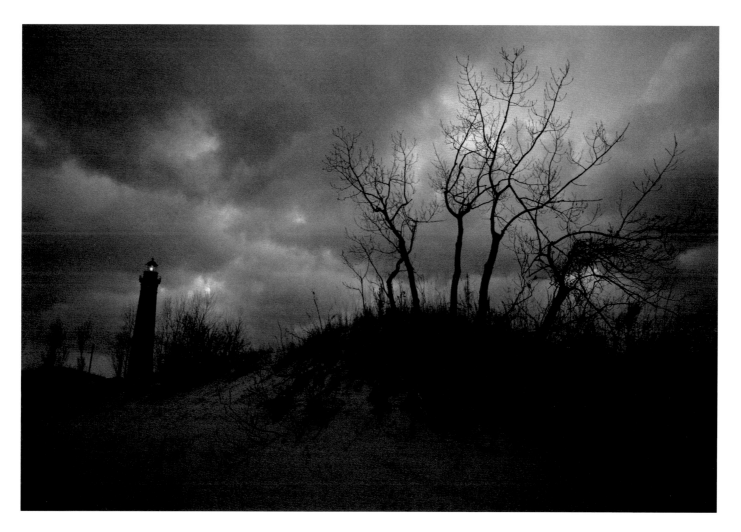

Silver Lake Lighthouse, Lake Michigan.

his loft, each net has been draped in time-honored tradition taught by his father at dockside so many years ago. The hours are long, the pay variable, but come each dawn the *Lelond LaFond* noses out of the Algoma harbor in search of the day's catch.

"Fishing is in my blood," he told me, "it's an obsession for me. There isn't a day that goes by that I don't think of the lake. When I was a kid, every day I had off school, I went out on the lake." Commercial fishing is part of the heritage of this region. It is something to be preserved at all costs, according to Andy. Time with a commercial fisherman puts a traditional workday in perspective. Up at dawn to load nets and prime the engine, the 45-foot vessel heads out of the harbor as the sun rests on the horizon.

We motor past 20 small boats of sport fisherman drawn to this region for coho and king salmon. Angling now dominates the economy of the lake, bringing in 100 times the income of commercial fishing. Few words are said as we pass through the ranks of Johnson out-boards, outriggers and downriggers. Depending on the placement of his nets, our trip can take one to three hours. Then the nets are hauled in by winches and the fish are placed on the boards for sorting.

As the ship rolls in the mid-morning swells, those with a predisposition for motion sickness search for a horizon line and fresh air. Meanwhile the crew cleans the day's catch, with cigarettes draped easily from the corners of their mouths and filleting knives moving rhythmically.

By mid-afternoon it's time to set the nets again, a procedure that relies on precision and dexterity to avoid tangling the 10,000 feet of line. The long trip home provides time for cleanup and perhaps, a short nap. That's if the weather is good. When the ship returns to port, the fish must be dressed and iced or smoked and then packed for eastern markets. Nets must be mended, hung to dry and packed away.

Then there is time to relax. With a beer in hand and early evening light coming through the window of the shed, Andy's eyes light up as he explains his feeling for the lake, his independent lifestyle and the long family tradition.

"I'll never sell this boat," he swears to me, with a set jaw and defiant eyes, "If no one else will ever use it, I'll plant it on my front lawn."

The sun had just begun to show a hint of pink that morning over the Indian fishing village of Naubinway. Situated on the most northern part of Lake Michigan, the town is remote from the steel mills, resort towns and cities of the lower lake.

Randy lit a cigarette and exhaled a stream of smoke into the moist lake air. It was a somber morning. Two days earlier, three men from the village had been killed in their fish tug, run down by a freighter.

"They were friends of mine," said Randy. "It seems like such a waste to die like that. They must have been down below cleaning fish and never saw the freighter." As the sun lifted above the horizon, Randy and his helpers slipped the lines from the dock and turned his fishing boat out to the lake.

Boxes of nets were stacked below, providing a soft bed for one of the crew. Another stood in the door staring silently over the water. Randy was on the helm with his white boots glowing in the faint light of the cabin. There is something pure about a work boat. The lack of amenities, the pungent mixture of smells and the endless motion of the boat speaks to a no-frills lifestyle and plenty of hard work.

Randy talked of going back to school, of maybe doing something different. But he was drawn to the lake. "You have no one shouting orders to you here," he said as he poured a cup of coffee from his thermos. "We also have a community here. You'll see what I mean at the funeral."

The next day the small Naubinway church overflowed with mourners for the lost fishermen. Afterwards, everyone went down to the docks where a small tug was to take a wreath of flowers out to the lake. When the small boat came to a stop in the flat-calm sea, two of the family slipped the wreath into the water and watched in silence as it drifted away.

The next morning as I left Naubinway, I could see Randy's boat already out on the lake heading for his nets.

Lake Michigan has a split personality. Its northern reaches are rich in natural resources of timber and copper ore. Its southern reaches gave birth to the age of steel. Carl Sandburg hailed its towns, its people and the energy of its industry.

He called Chicago,

*"Hog butcher for the World,*
*Tool Maker, Stacker of Wheat,*
*Player with Railroads and the Nation's Freight Handler;*
*Stormy, husky, brawling*
*city of the Big Shoulders . . ."*

The helicopter made a close pass over downtown Chicago and then headed south along Lake Michigan's urban coast. The bird's-eye view of the coast reveals a battle line between man and nature. The sandy beaches have for centuries provided the buffer zone between land and the relentless movement of waves. But cities, the harbor breakwater and dredge spoils are physical barriers that have changed the shape of the shoreline.

From the air, the lake has struck a tentative truce with the concrete and asphalt world of Chicago and its coastal suburbs. The water changes color as it skirts the windy city, and a hazy stream of smoke from industry slides across the lake like a veil.

Flying over the steel complexes of East Chicago, Gary and Burns Harbor, is like flying into the bowels of some distant world, a world where road warriors might rule. There is a century of history in these mills, where steel helped create an industrialized America. Today the mills are still the terminus for much of Lake Superior's taconite (pelletized iron ore). But with competitive foreign ore and steel, a strong U.S. dollar, and the shift away from steel into other metals and high tech ceramics and plastics, the steel industry is fighting for its life.

He was walking towards me on the bridge over the Indiana Ship Canal, wearing a black hero jacket, combat boots and camouflage pants. His eyes had a piercing quality that challenged you. While his uniform might suggest otherwise, he was very much at home in steel town.

"That's Bethlehem Steel," he answered in response to my question. Before long, we were sitting in a local bar, where a steady stream of people walked in, bought a six pack and quickly left. Through the window, I could see three guys in a pickup, drinking beer in the parking lot.

"I've always remembered these mills," he said. "They had this long catwalk to the parking lot, over the railroad tracks, over the cars and stuff. I used to sell ice cream to steel workers as they left work across the catwalk. I remember sitting there looking at the smoke lifting off the roof vents of the hearths and there wasn't any doubt that I'd be working there." We finished our beers and went back to his two-room apartment where he was finishing his work as a leader in the local Vietnam Vets organization.

"The Vietnam war came along and I wanted to fight . . . I felt a lot for my country. You might say my patriotism was almost burned into my skin. I knew I'd come back and have work and it seemed like a way out of this grind for awhile. But when I came back, no one cared where I had been and worse, it was tough finding work. Those days of plentiful work in the mills were gone." We spent the afternoon walking along the streets of East Chicago, Gary and Indiana Harbor. In some places it looked as if war had been waged here, rather than thousands of miles away.

The next day, my friend helped in a food shelf program for unemployed steel workers during the Christmas season. Large truckloads of food had to be unloaded and bagged while long lines of people waited for their share.

"Why stay," I asked. "That's what you always hear. Get some computer training and go to California," he responded angrily. "Look at me and these families. You tell them to pack up and leave their neighborhood and friends and go out and do computers. Sure we have to train and adapt, but dammit, this is our home."

The morning mist hangs in layers over Grand Traverse Bay and the hillside vineyards of Old Mission Peninsula. The low morning sun tinges the sky a soft rose and highlights the pale green outlines of distant forests and nearby vineyards of Riesling and Chardonnay.

Grand Traverse Bay stretches from Old Mission Peninsula to the Leelanau Peninsula, and beyond that narrow strip of fertile farmland lie the northern reaches of Lake Michigan. The scene is an endless panorama of land and water, of rich green vegetation

and turquoise water, found no where else in the Great Lakes Basin. Caribbean-like in its color and clarity, the water of Grand Traverse Bay is an inspiration to view.

"A view of the Bay for half the pay," said Mark, the winemaster at one of the local wineries. "I don't mind making less than I might in a factory job. I'm doing what I want to do for the rest of my life. And this is the best place to do it."

The waters of Lake Michigan and Grand Traverse Bay create a microclimate, protecting the peninsula from deep freezes in the winter and extremely hot weather in the summer. This microclimate has nurtured the large fruit-growing industry in the region and has helped Michigan become the third largest wine-growing state in the nation.

"There used to be nothing but potatoes here," said Mark. "Then people discovered they could grow apples, peaches and cherries. Now you can make a living growing 20 acres of grapes, where it once took 100 acres of cherries."

Testimony to changing industries and economies, the vineyards have grown along the hillsides of Grand Traverse Bay.

On a warm, summer day, I followed Mark through the vineyard as he trimmed the endless row of vines. He had become fascinated with winemaking while working as a social worker in Germany. "I needed to do something with my hands," he explained, "I wanted to have something tangible I could show for my work at the end of the day."

His days are full of tying and pruning and monitoring sugar content of the grapes. But much of his work is inside the winery as well. Surrounded by steel vats and oak barrels, he monitors the aging process and samples the wine.

"Vines symbolize life and growth and the will to survive. I wanted to start something my children might want to continue. You see, not all industries are leaving. New ones are beginning. I'm excited to be part of something new. I like the fact that I can grow some of the highest quality grapes right here on the Great Lakes."

I last saw Mark during the harvest time. He was surrounded by friends and family who had come to help with the first harvest of his own vineyard. The high-pitched voices of children blended with the

monotone sounds of adults, visiting as they worked their way through the rows of vines. There was an air of excitement, an expectation that this was an event that would become an annual tradition. Something new was beginning amid the hillsides of Old Mission Peninsula.

.    .    .

It's hard to separate what impact the lakes, land and people have on one another, or to know which has changed the other most. There is no question that a symbiotic relationship exists among them. Like migrating geese that follow familiar landmarks imprinted on their senses, many of us in the Midwest have been imprinted by one of the Great Lakes and return to them, time and time again, as our physical or spiritual home. These lakes, together with the land and people, weave a rich tapestry of life that is the soul of the region.

The diverse beauty of Lakes Superior and Michigan has touched all who've had the opportunity to experience it. Whether it is the dramatic shoreline and wilderness reaches of the north, or the resorts and sand dune shoreline of the south, they speak to our need for space and grandeur. The lakes put our lives in perspective to the larger and ever-changing forces of nature and time. They give us a sense of place and allow us to develop a relationship with them.

The quality of their environment must be preserved as much for our own need for beauty, solitude and majesty, as for the integrity of the ecosystem of which we are a part. Unlike the person who returns to his childhood home, where the streets seem smaller and the buildings shorter than remembered, Lake Superior and Lake Michigan will always retain their awesome quality and provide us with a much needed sense of wonder.

# DISTANT SHORES

PHOTOGRAPHS FROM LAKE SUPERIOR AND LAKE MICHIGAN

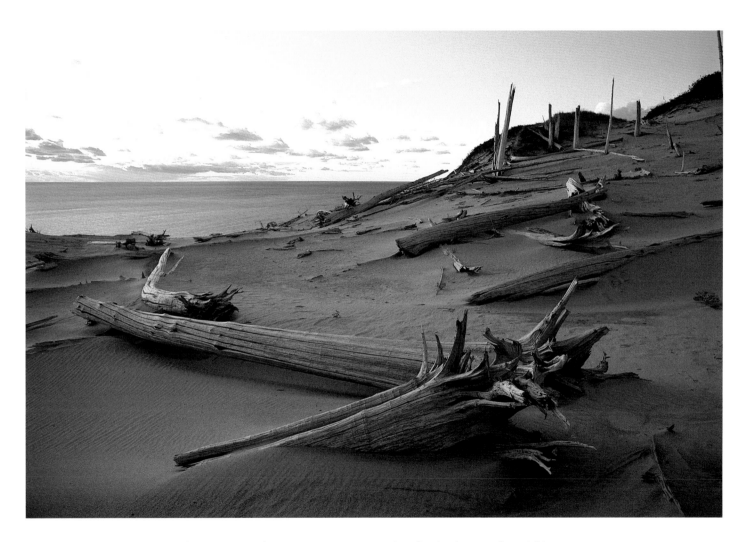

Ghost Forest, Sleeping Bear Dunes National Lakeshore, Lake Michigan.

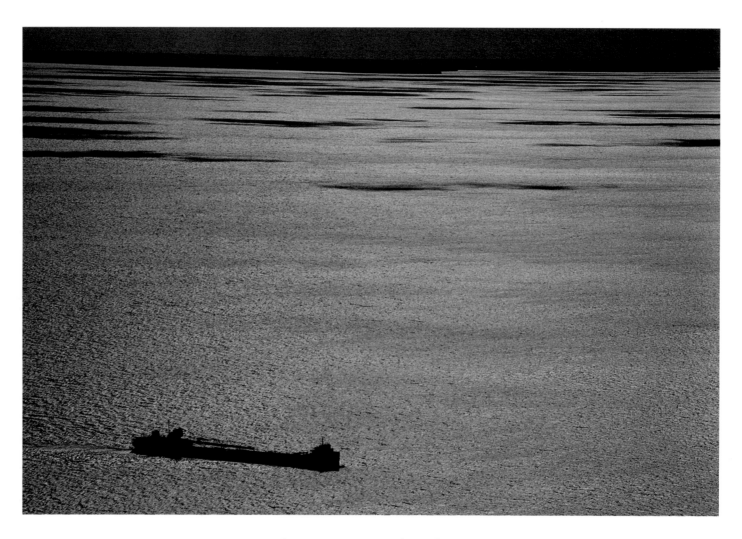

Laker crossing upper Lake Michigan.

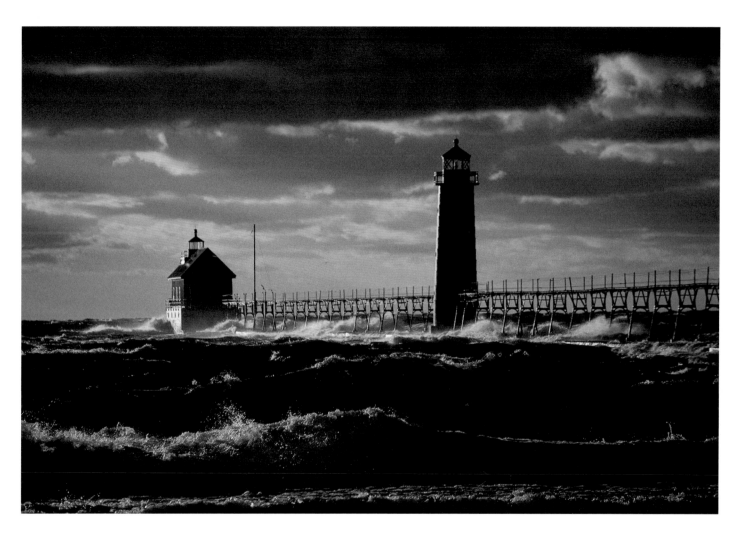

Evening squall, Grand Haven, Michigan.

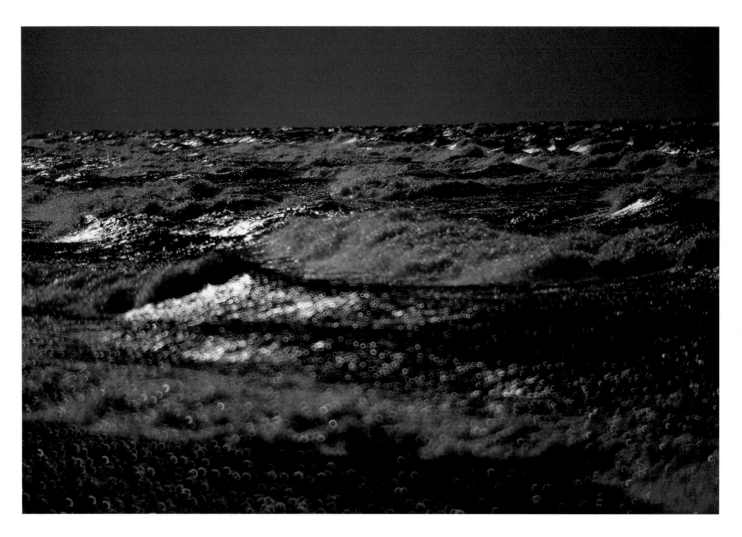

Storm on Whitefish Bay, Lake Superior.

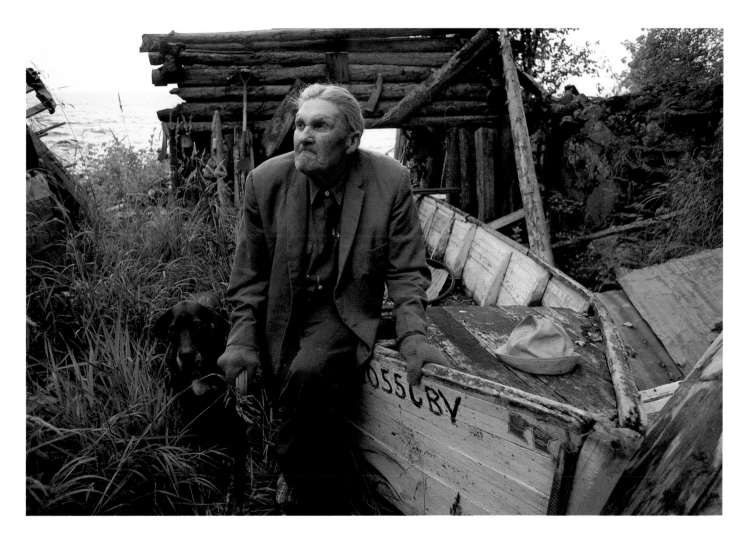

Helmer Aakvik at his boat house, Hovland, Minnesota.

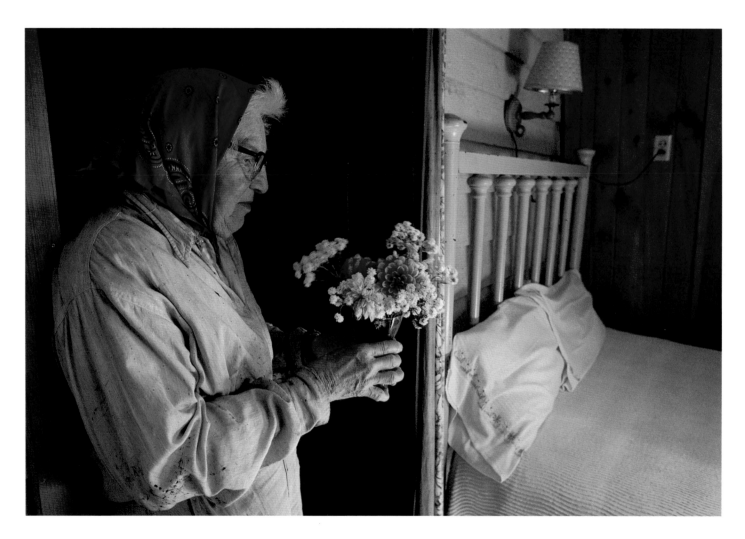

80th Birthday at North Shore cabin, Lake Superior.

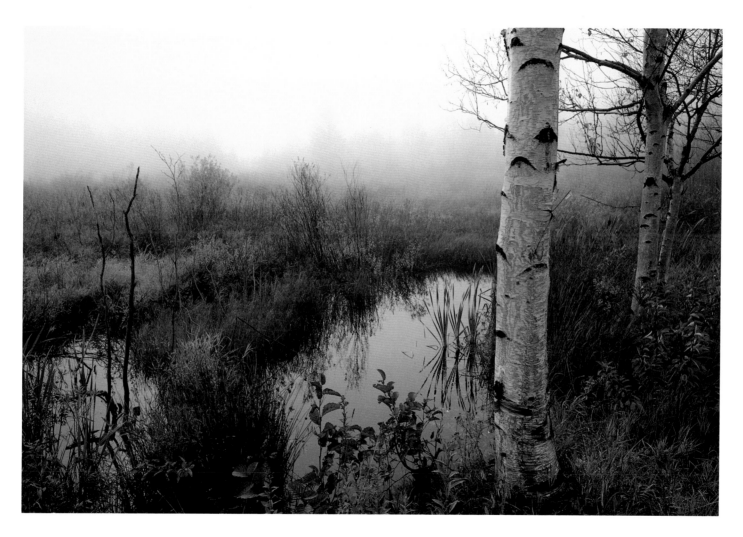

Morning fog, northern Lake Michigan coast.

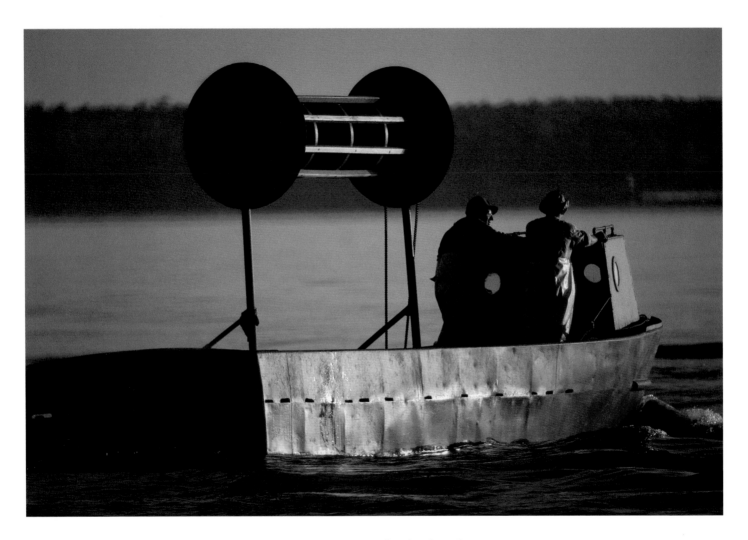

Commercial fishermen, Apostle Islands, Lake Superior.

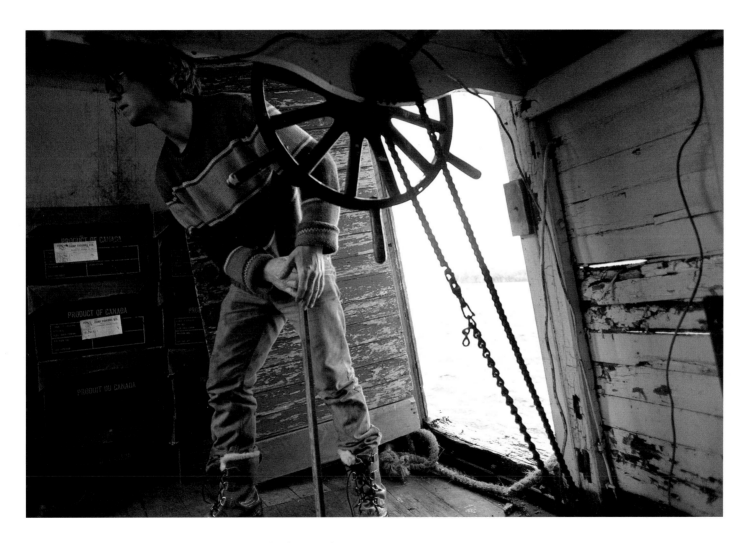

North Shore fisherman, Beaver Bay, Minnesota.

Leland Harbor, Lake Michigan.

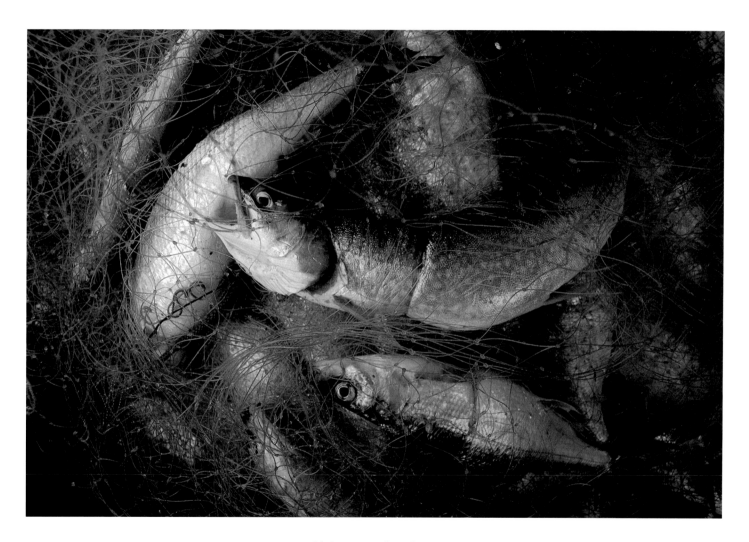

Herring and lake trout, Thunder Bay, Ontario.

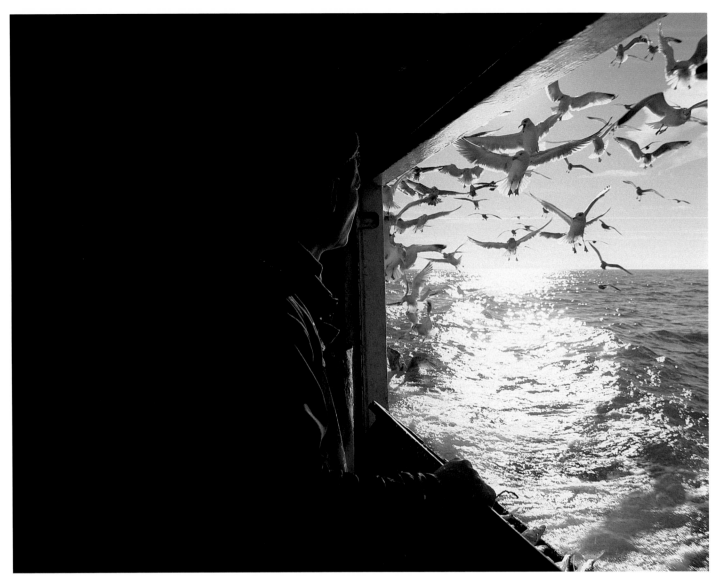

Lake Michigan commercial fisherman.

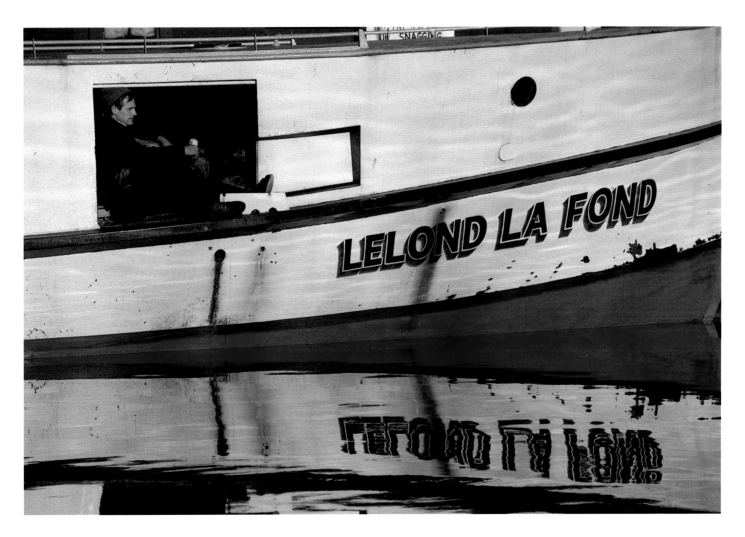

The *Lelond La Fond*, Algoma, Wisconsin.

Diner in Sault Ste. Marie, Michigan.

Whitefish Point, Michigan.

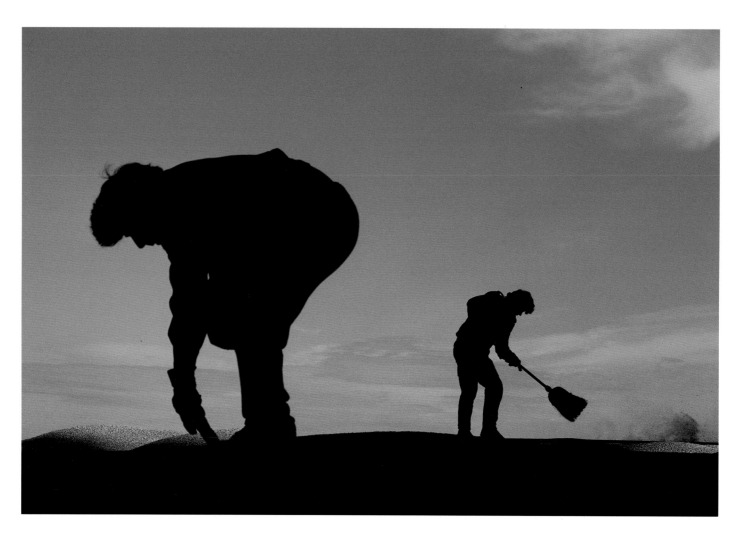

Cleaning grain ship hatch covers, Duluth-Superior harbor.

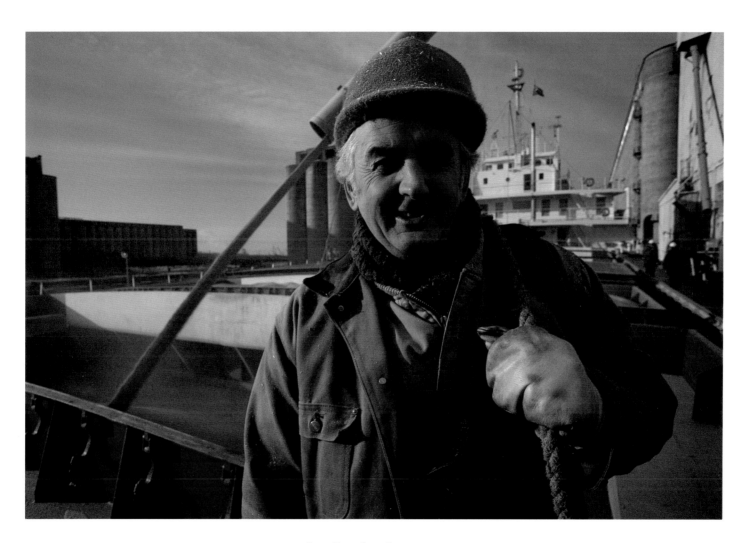

Grain handler, Thunder Bay, Ontario.

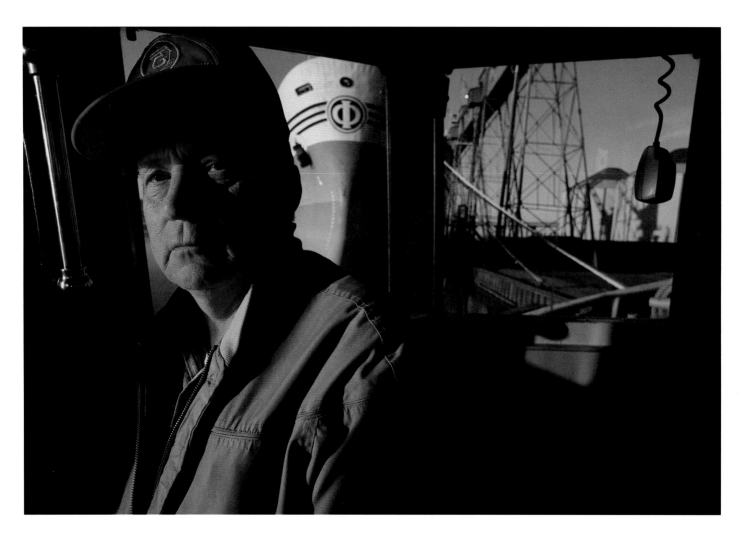

Lake Superior tug captain, Duluth, Minnesota.

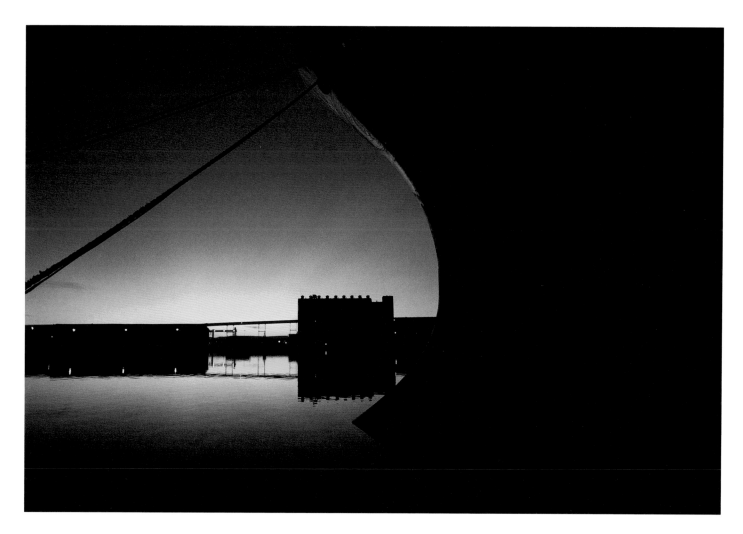

Sunset at Duluth-Superior harbor.

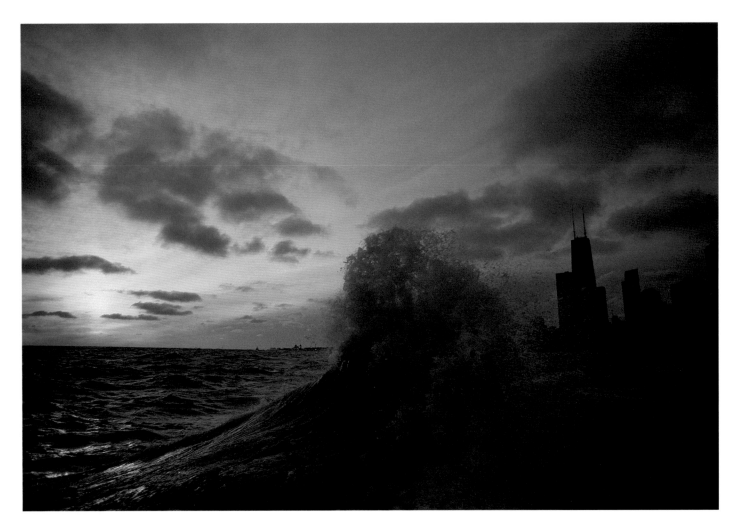

Chicago, waterfront.

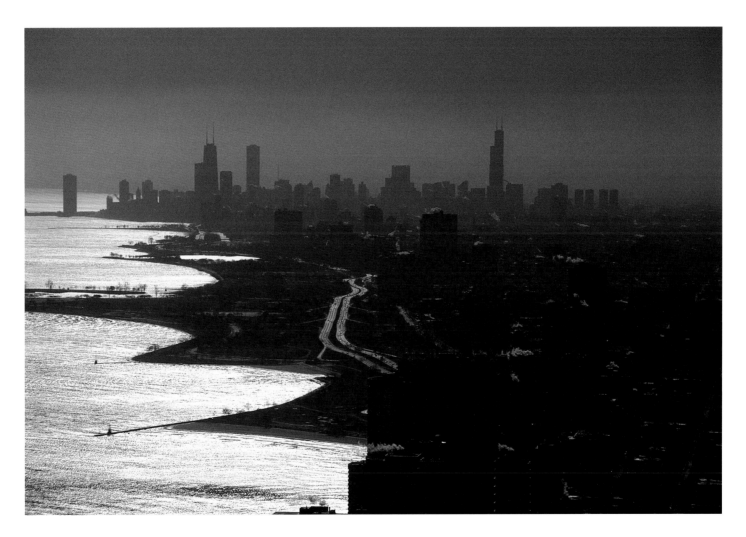

Lake Michigan coast, Chicago, Illinois.

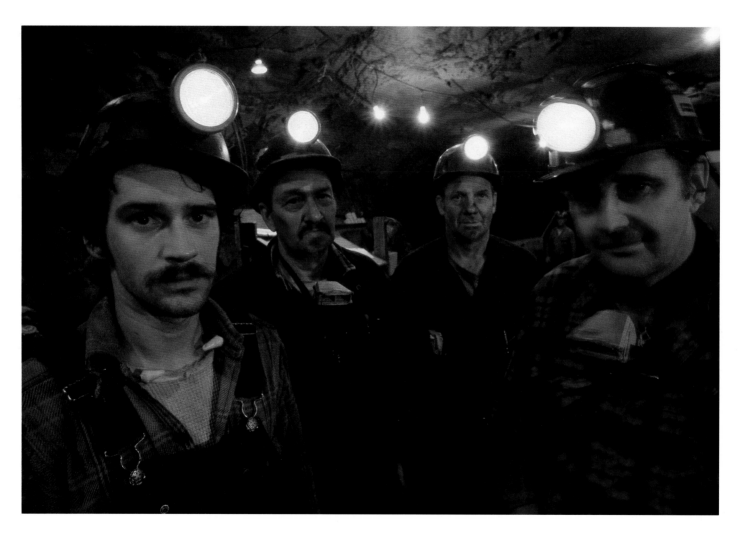

White Pine miners, Upper Peninsula, Michigan.

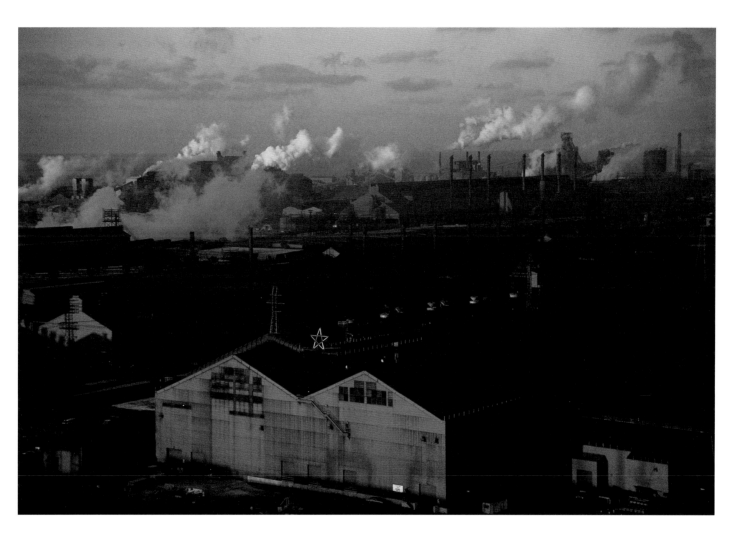

Steel mills, Gary, Indiana.

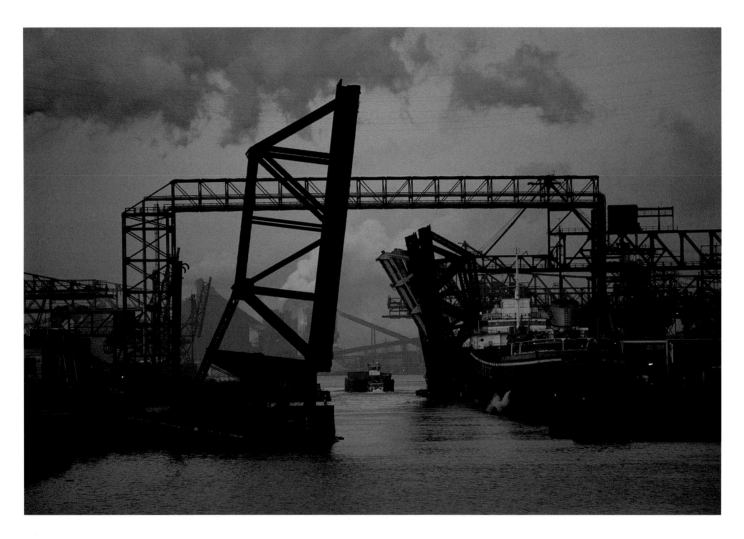

Indiana Harbor Canal.

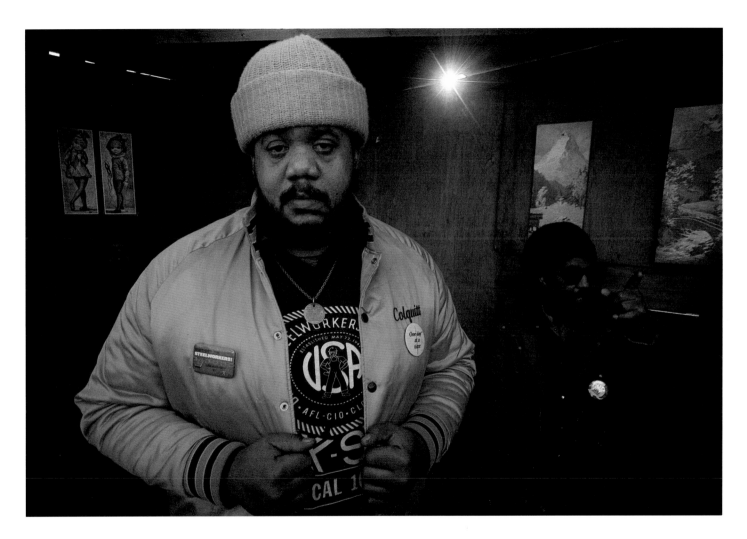

Steelworker, Gary, Indiana.

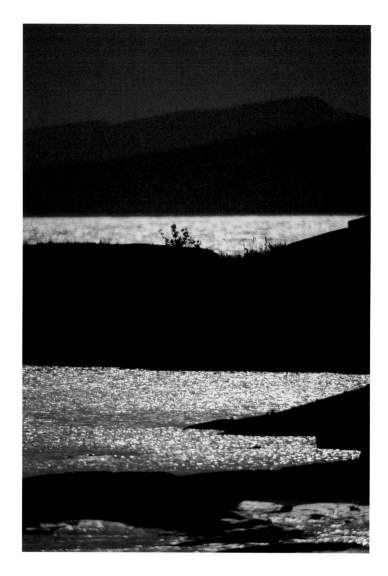

Sawtooth Mountains, Lake Superior North Shore, Minnesota.

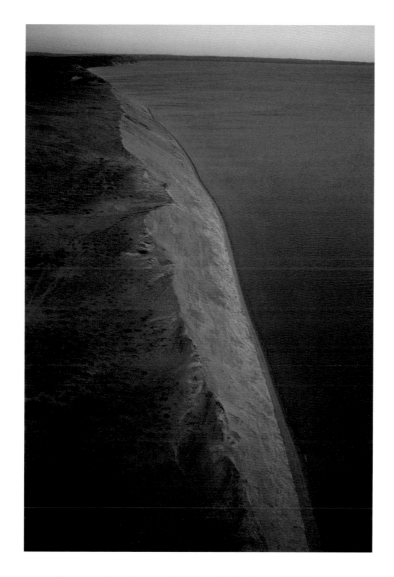

Sleeping Bear Dunes National Lakeshore, Michigan.

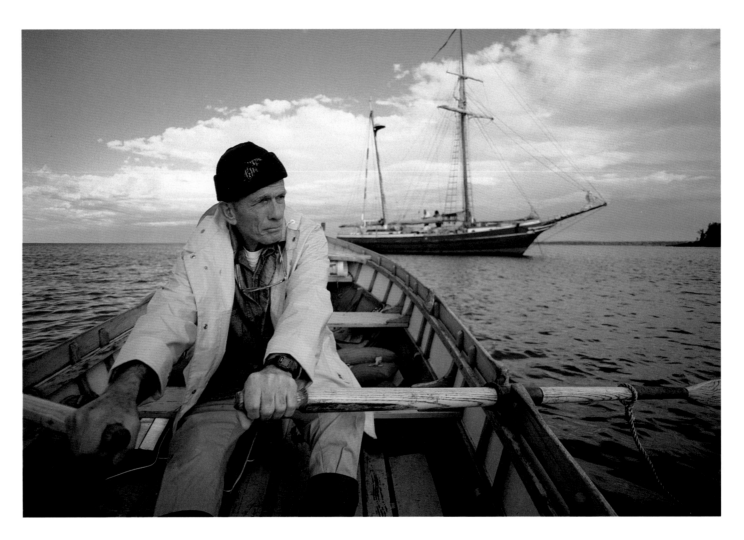

Captain of the *Sheila Yeates*, Apostle Islands, Lake Superior.

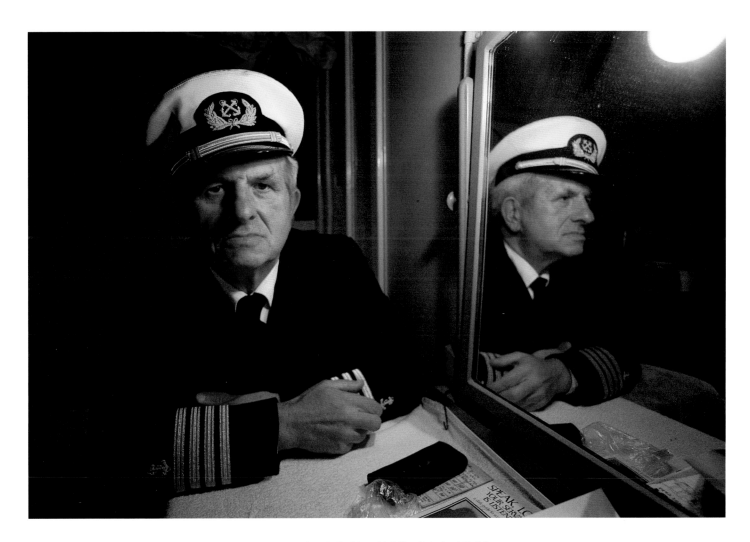

Ferry Captain, S.S. *City of Midland*, Lake Michigan.

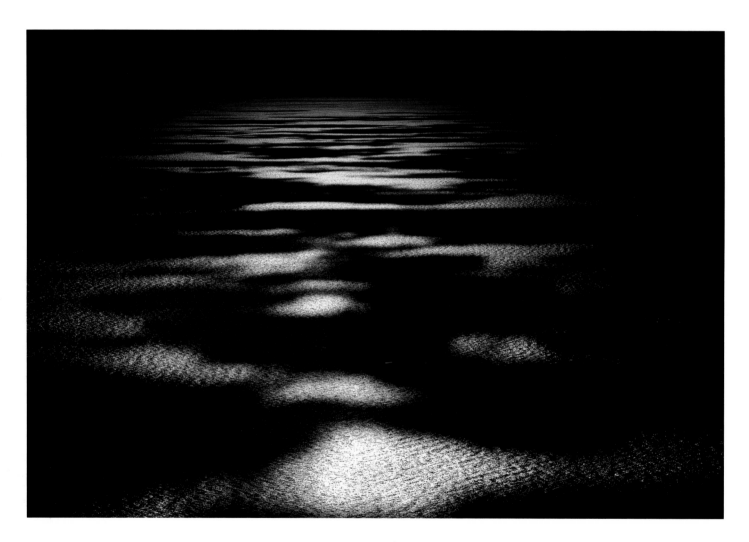

Winter crossing, Lake Superior.

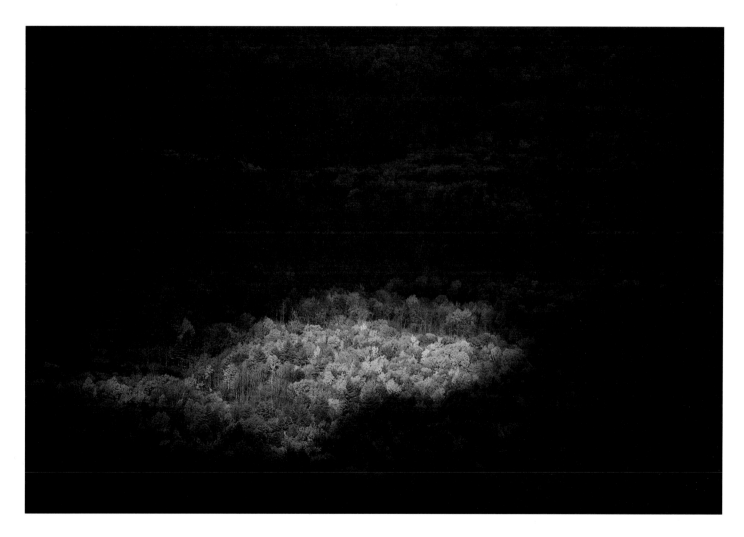

Autumn, Traverse City, Michigan.

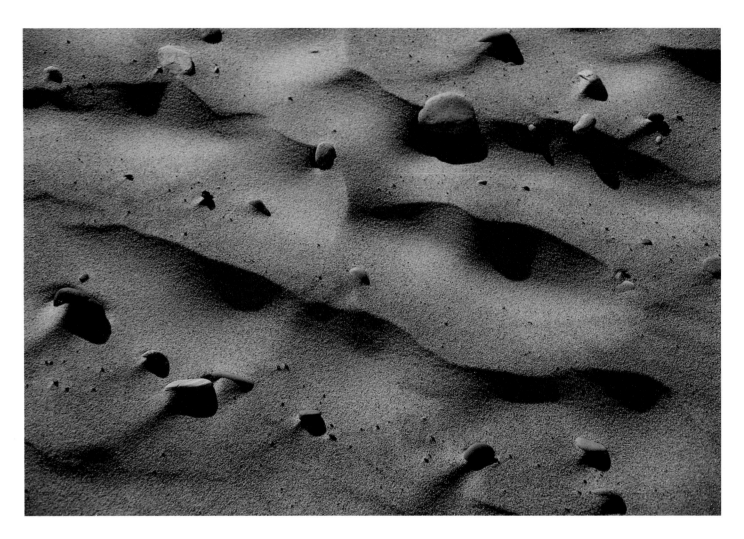

Whitefish Point, Lake Superior.

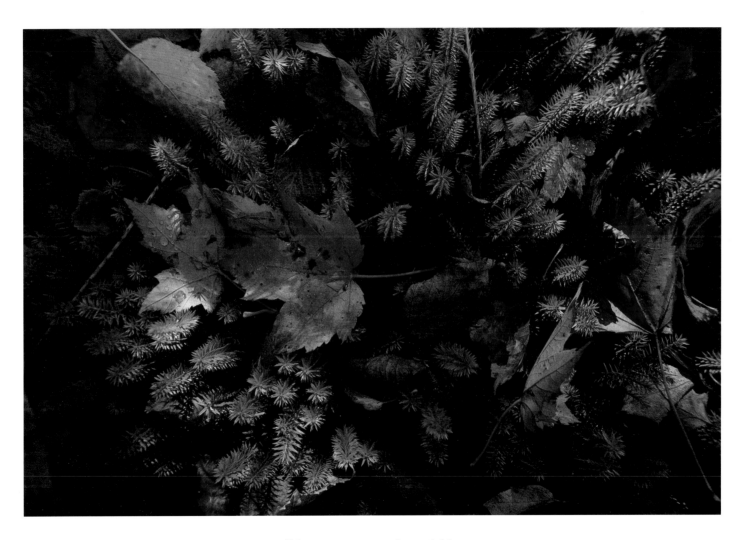

Fall forest, Copper Harbor, Michigan.

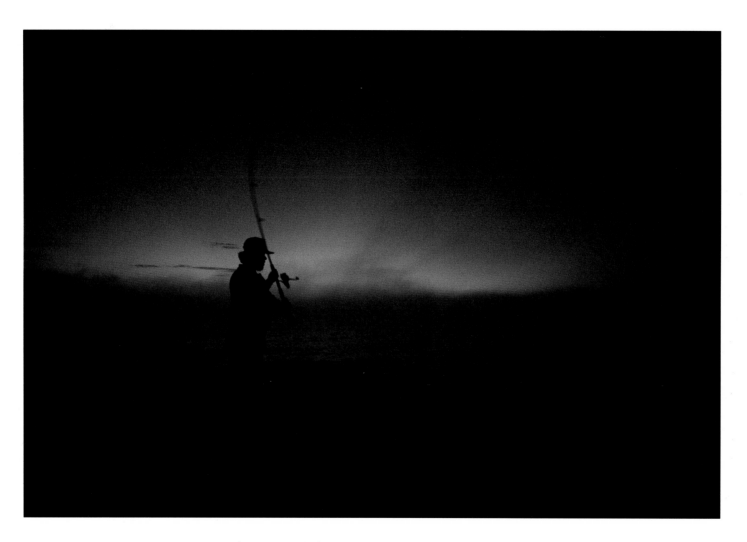

Lake Superior fisherman, Upper Peninsula, Michigan.

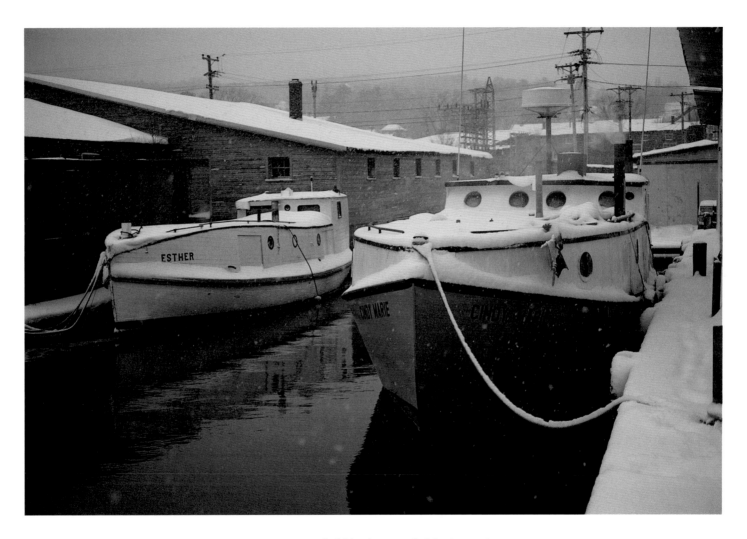

Winter at Bayfield harbor, Bayfield Wisconsin.

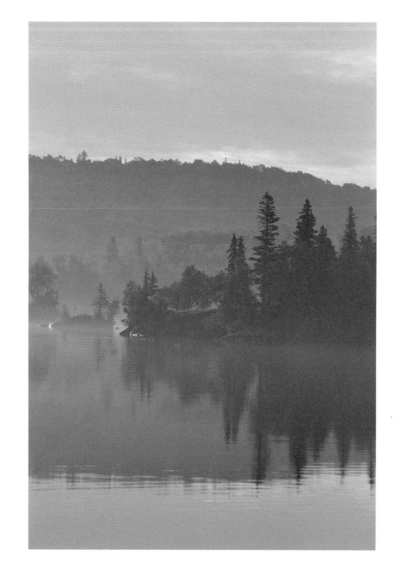

Morning mist on Isle Royal, Lake Superior.

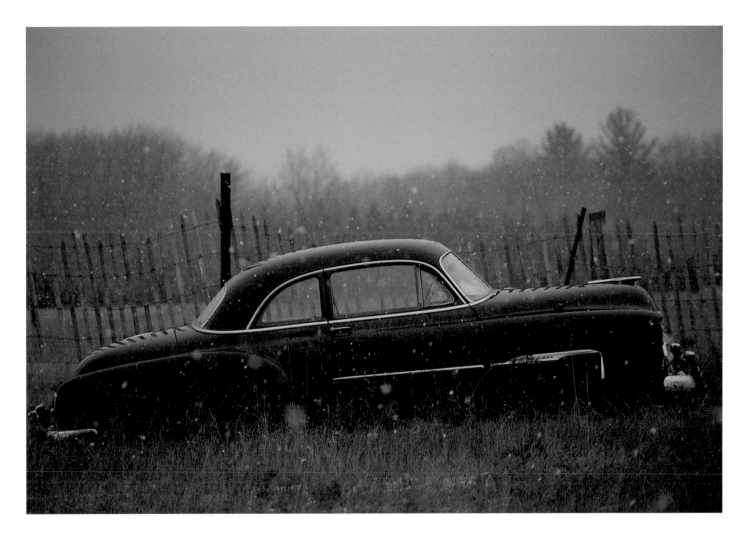

First snow, Upper Peninsula, Michigan.

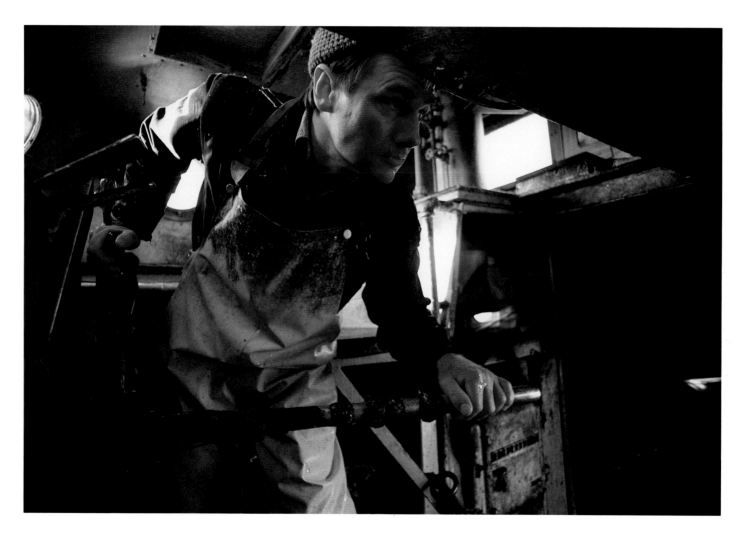

Docking the boat, Algoma, Wisconsin.

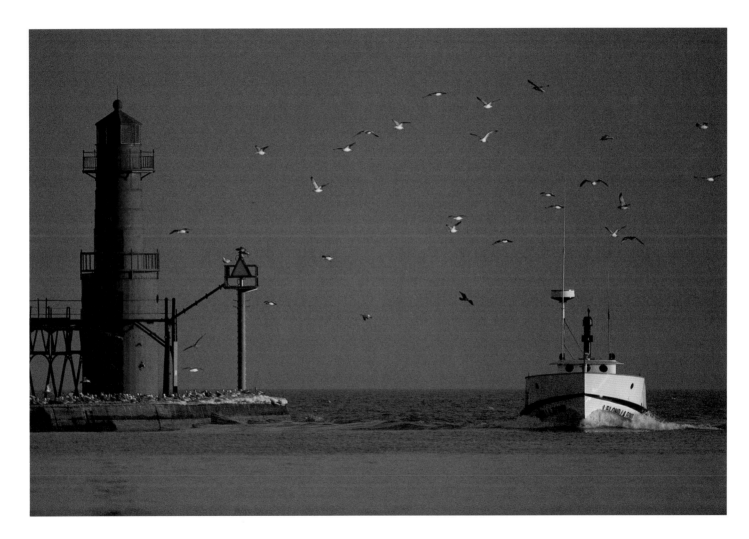

Algoma Light House, Lake Michigan.

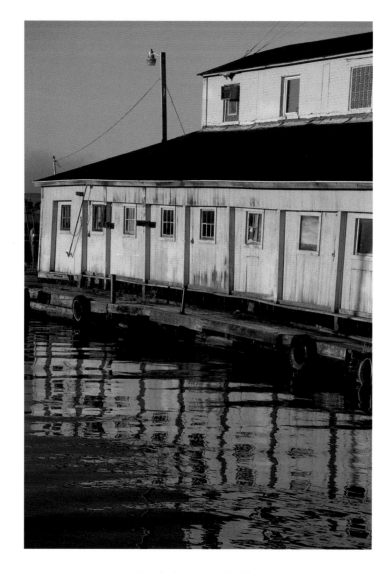

Commercial fish docks, Bayfield, Wisconsin.

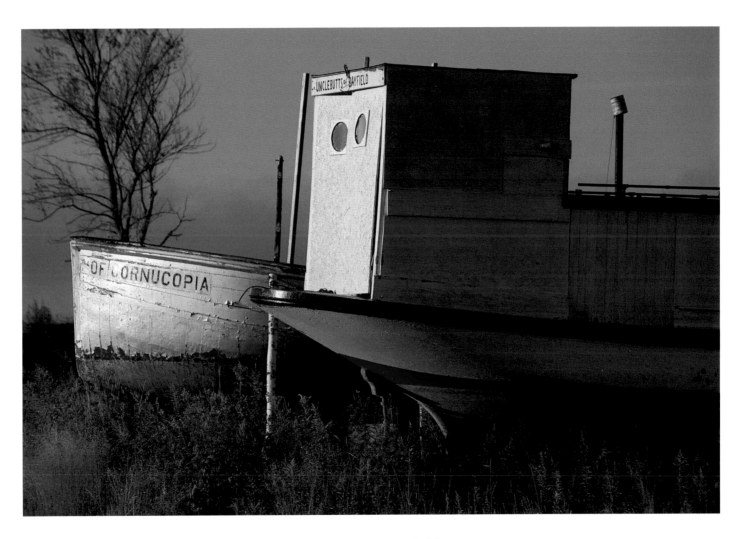

Fish tugs hauled for winter, Bayfield, Wisconsin.

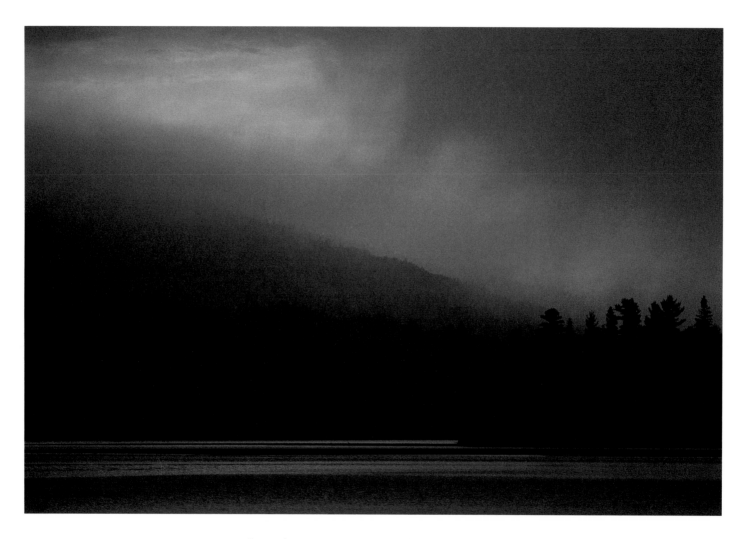

Lake Bailey, Keweenaw Peninsula, Lake Superior.

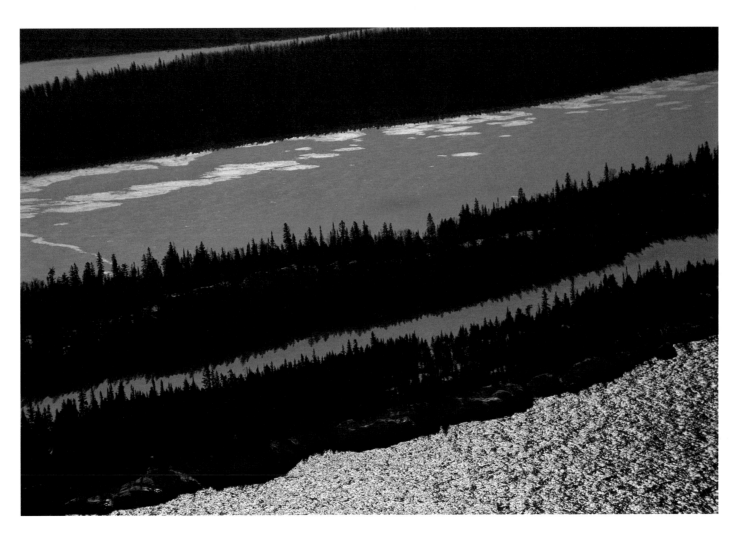

Winter ice, Isle Royale National Park, Lake Superior.

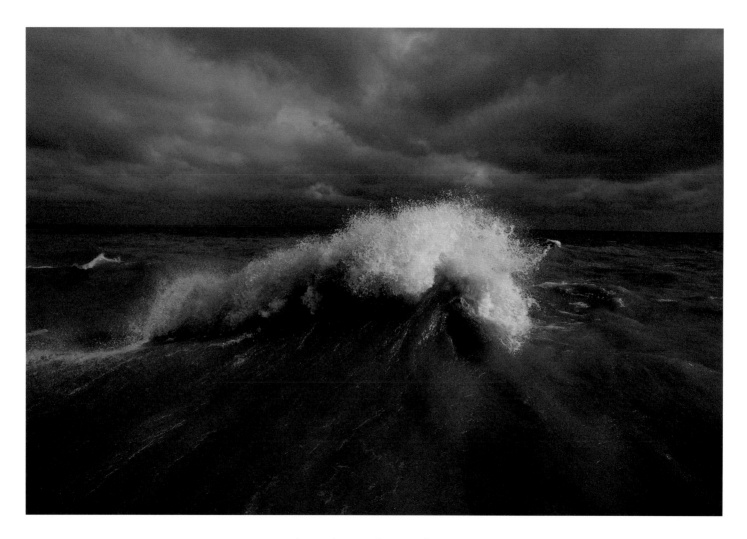

Lake Michigan, Chicago, Illinois.

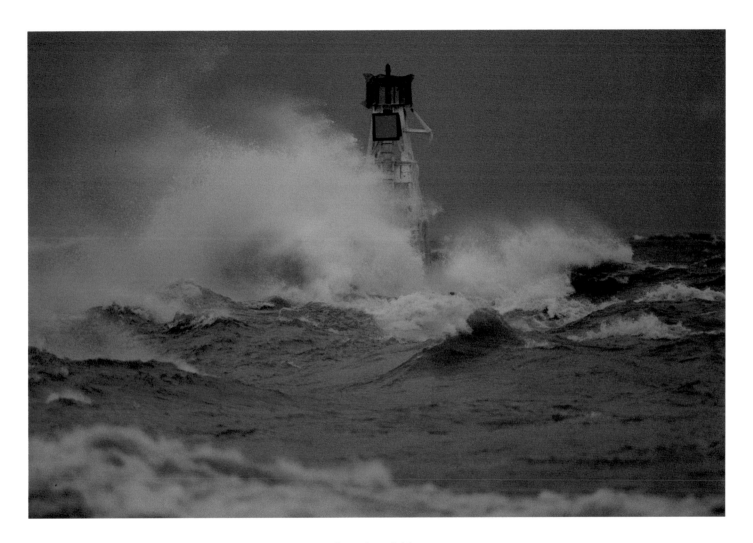

Gale, Lake Michigan.

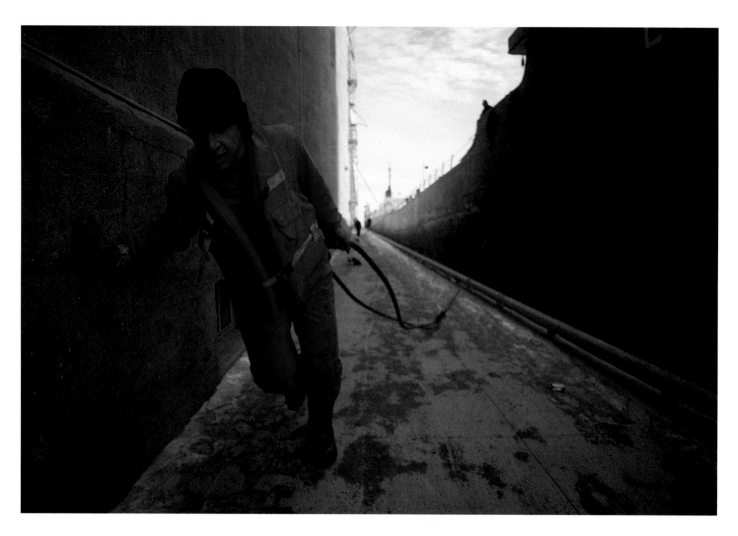

Docking grain boat, Port of Thunder Bay, Ontario.

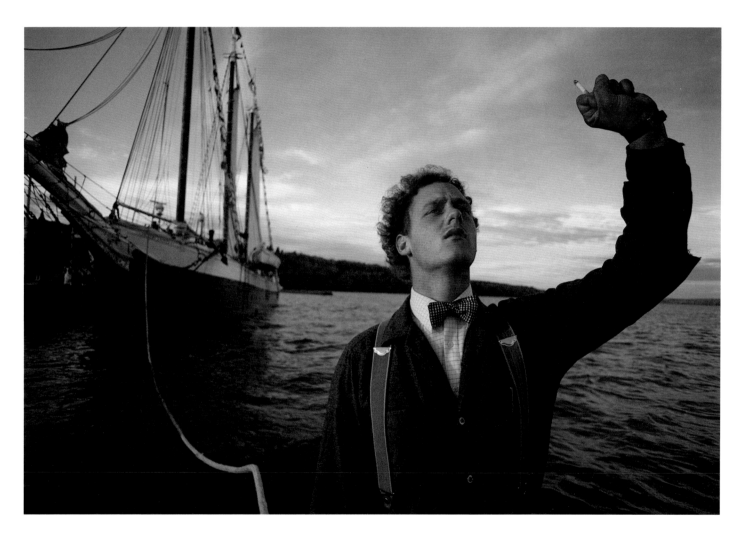

Towing the *Victory Chimes*, Apostle Islands.

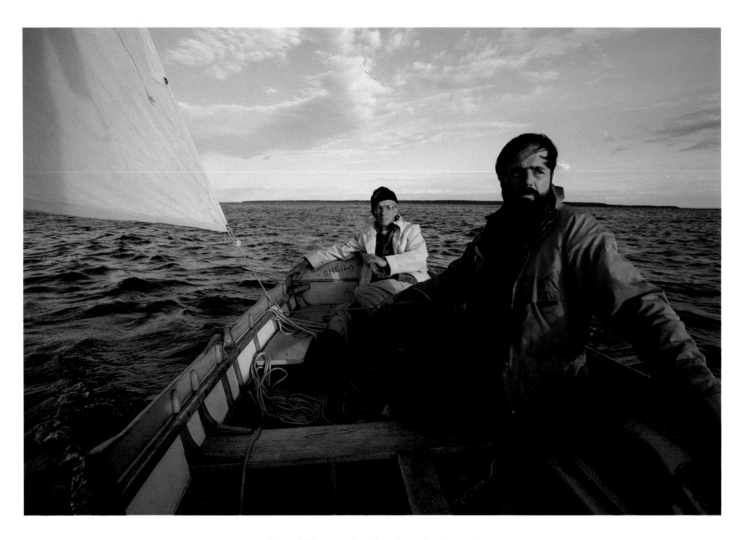

Sailing skiff, Apostle Islands, Lake Superior.

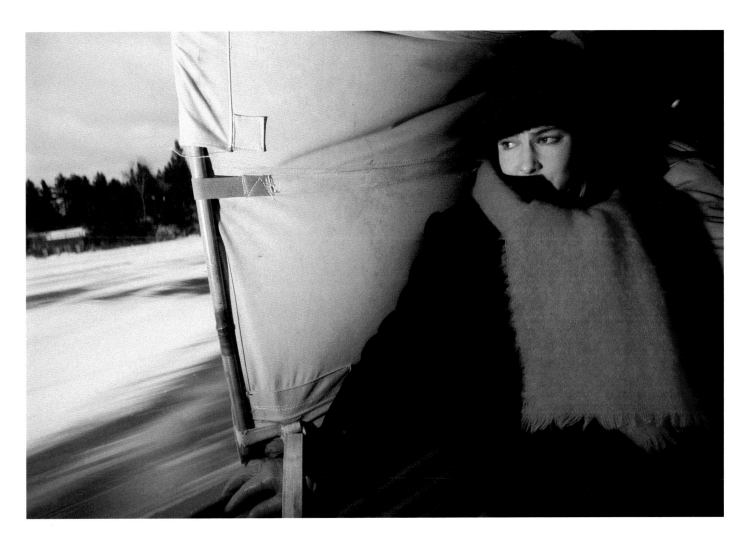

Crossing to Madeline Island on ice sled, Apostle Islands.

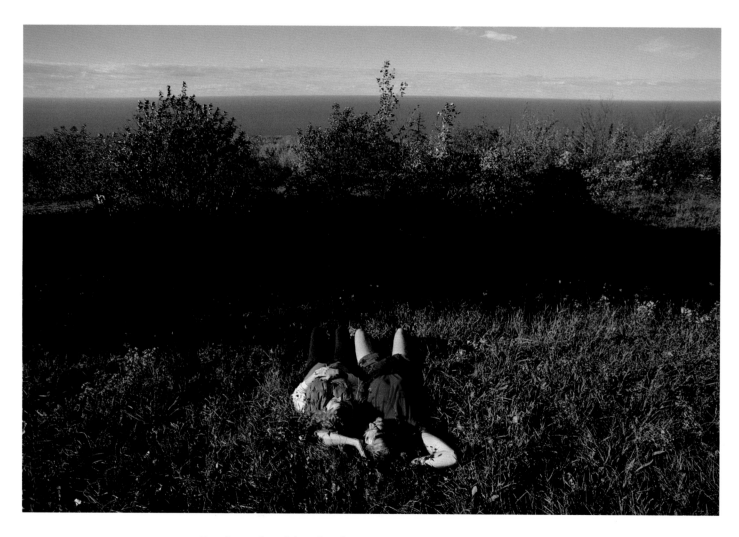

Road to Lake of the Clouds, Porcupine Mountains, Michigan.

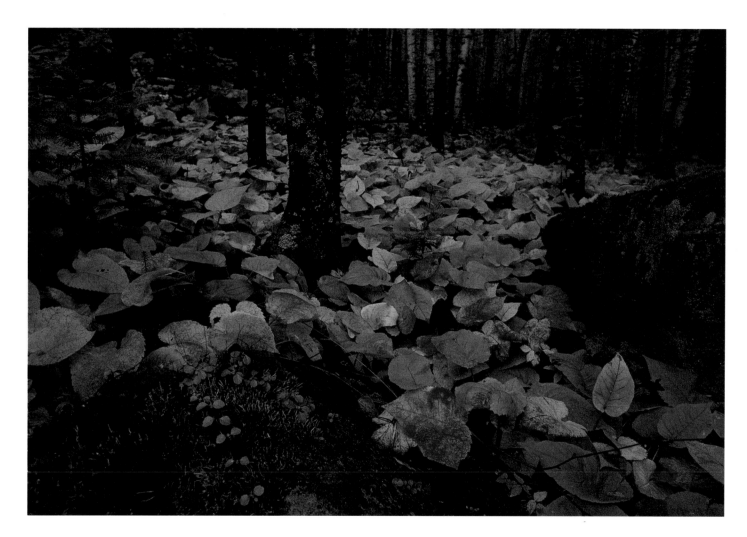

North Shore forest, Lake Superior.

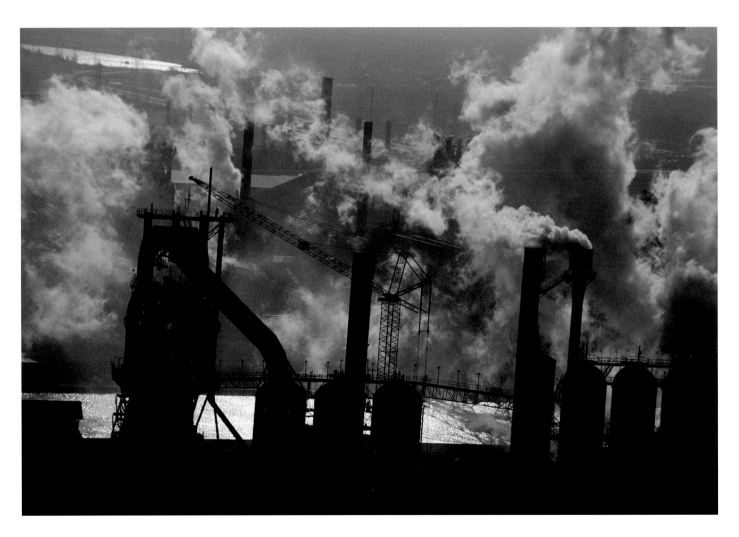

Indiana Harbor, Lake Michigan.

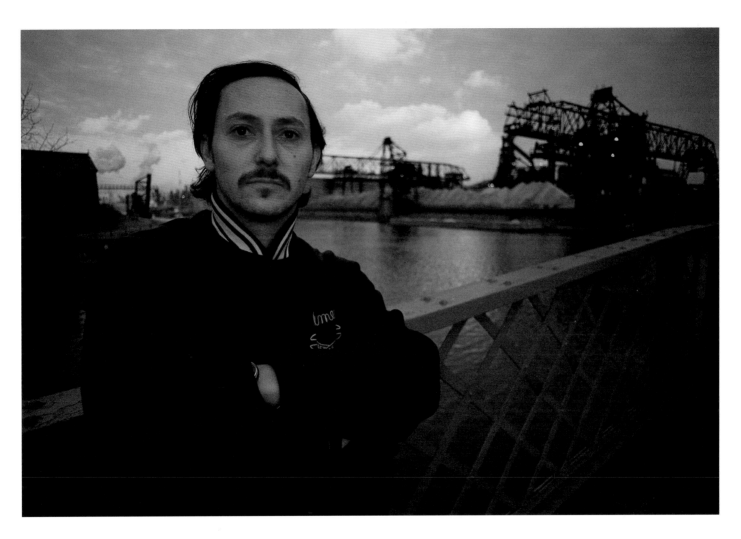

Indiana steelworker.

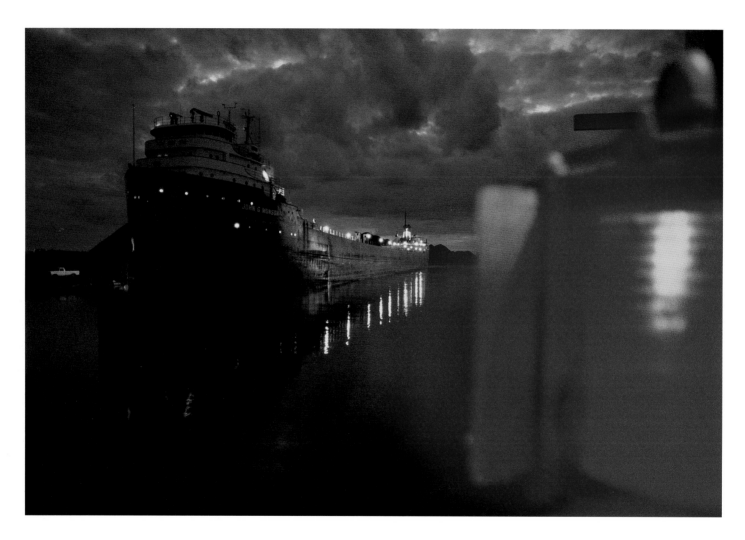

Commercial docks, Ontonagon, Michigan.

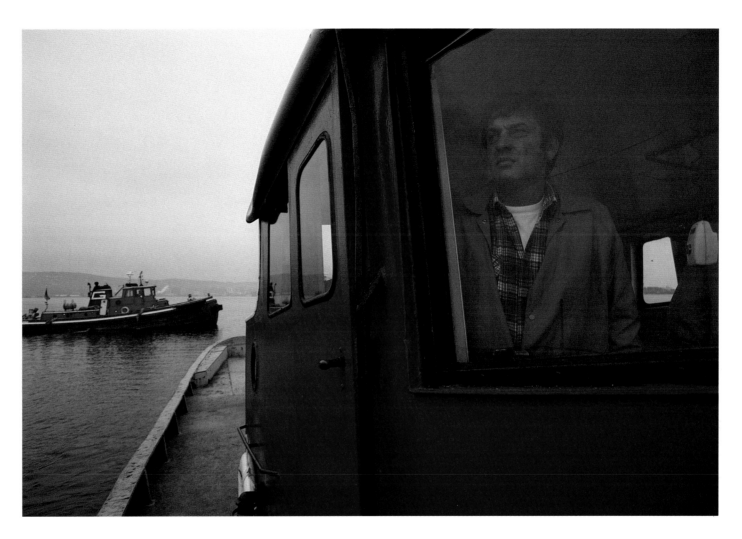

Harbor tugs, Duluth, Minnesota.

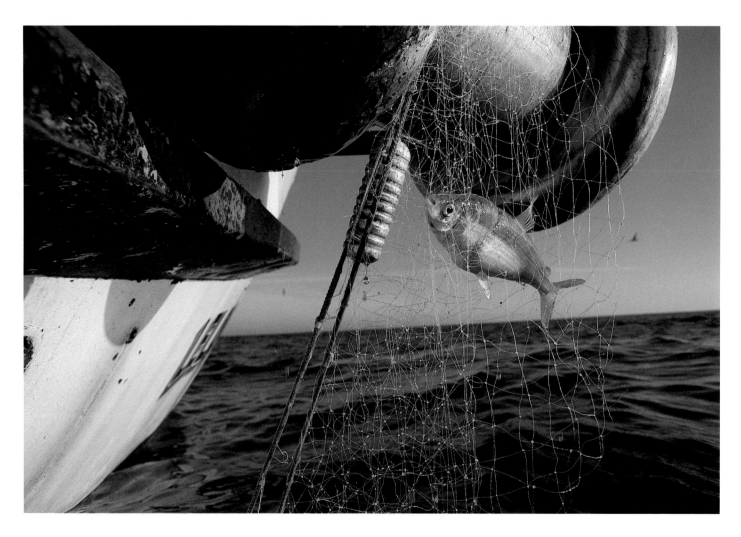

Lake Michigan chub.

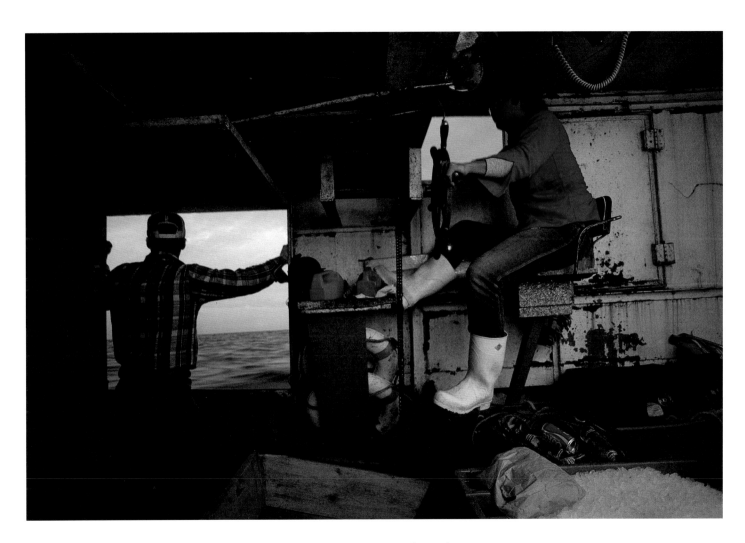

Naubinway fishermen, Lake Michigan.

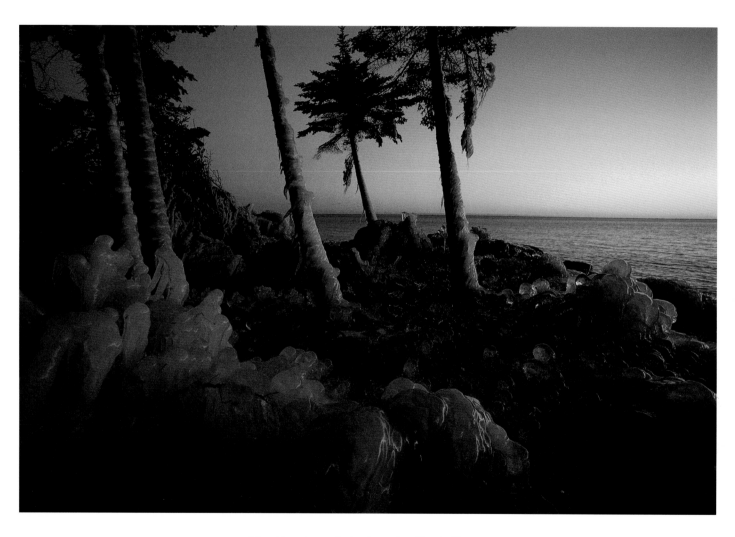

After the storm, Lake Superior North Shore.

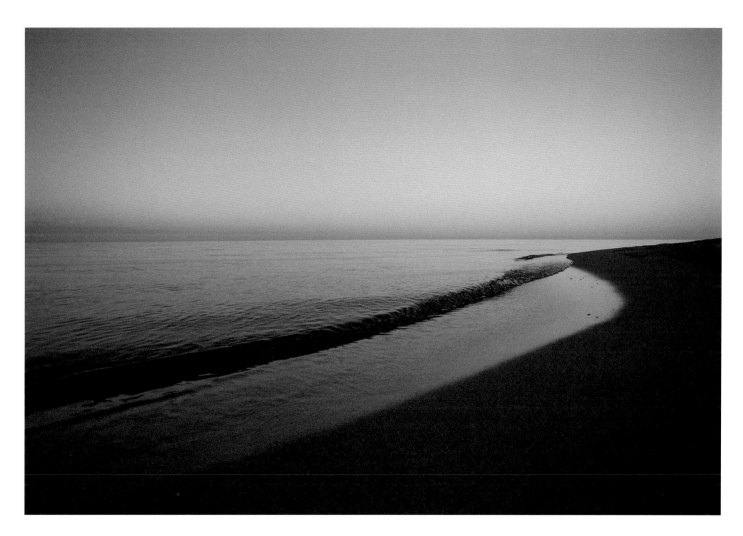

Lake Superior South Shore.

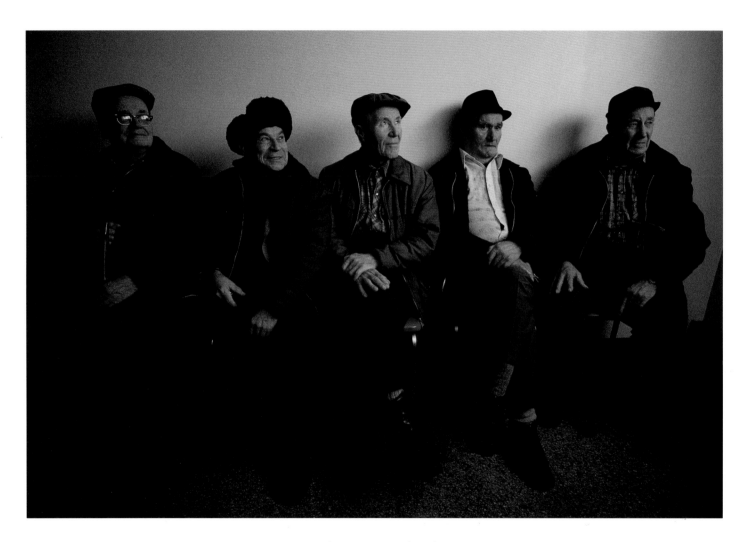

Men's room, Finnish restaurant, Thunder Bay, Ontario.

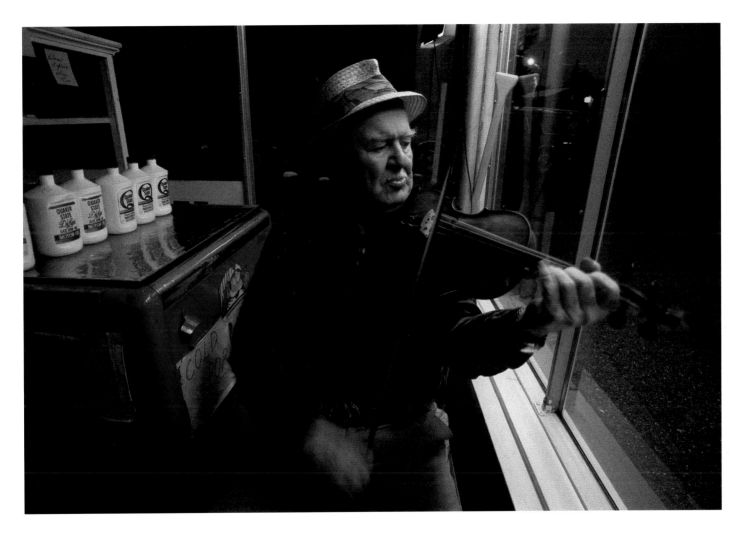

Finnish fiddler, Copper Harbor, Michigan.

Fish Camp, Whitefish Point, Michigan.

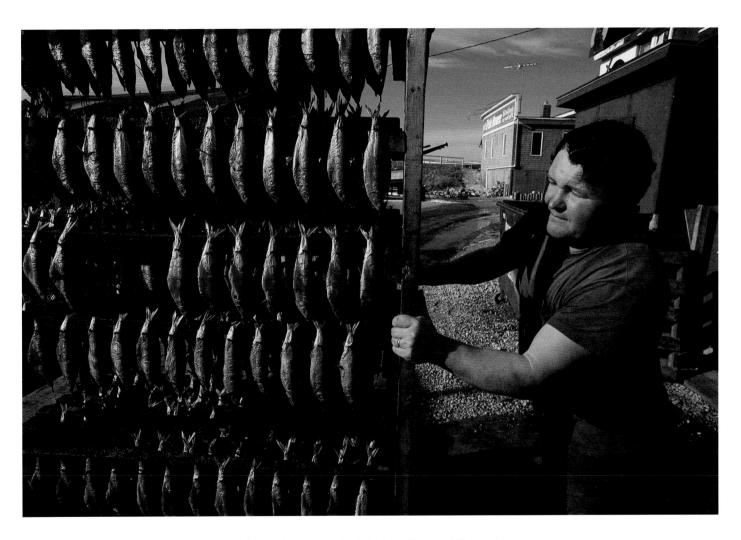

Lake Michigan smoked chubs, Algoma, Wisconsin.

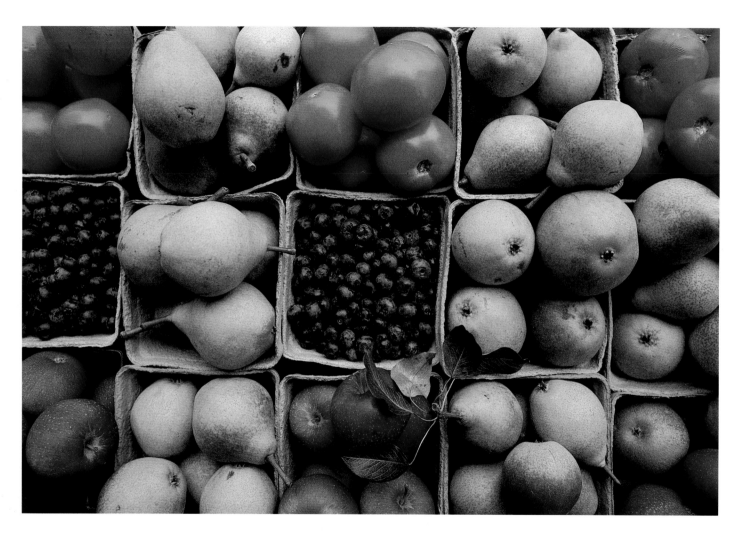

Fruit Harvest, Old Mission Peninsula, Michigan.

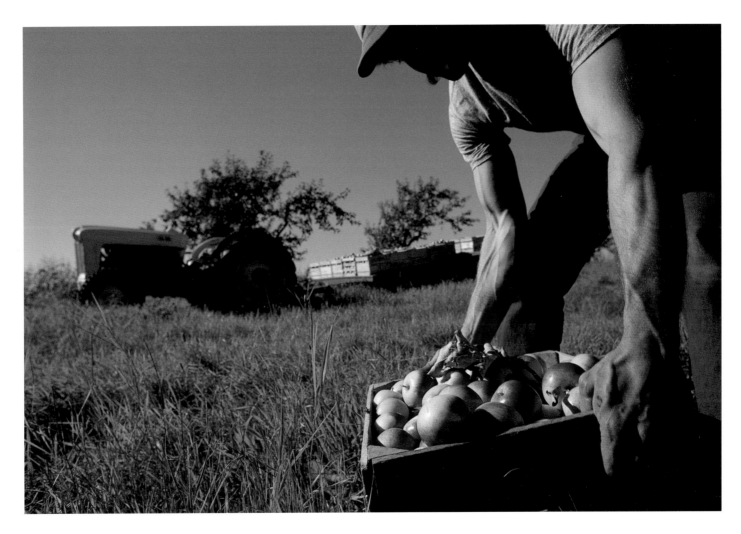

Bayfield apple orchard, Wisconsin.

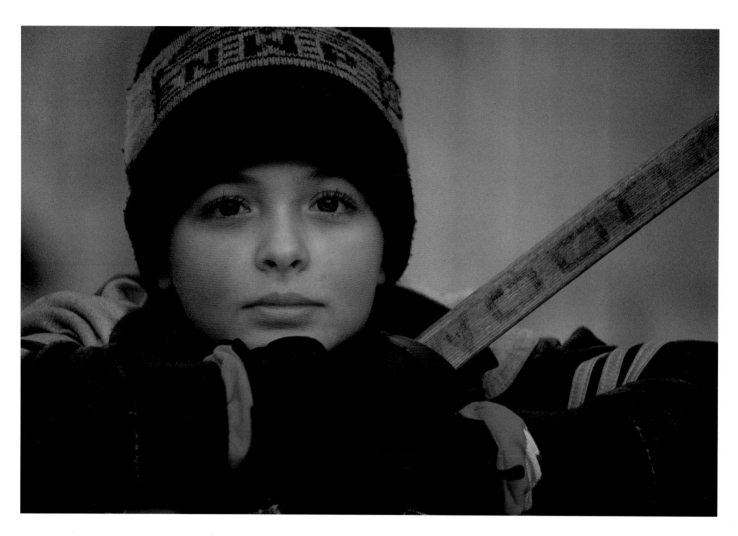

Hockey player, Thunder Bay, Ontario.

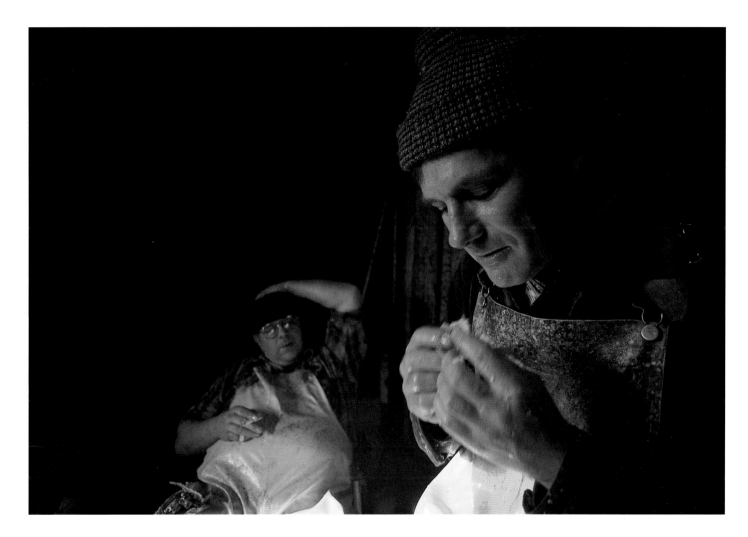

Eating smoked chub, Lake Michigan.

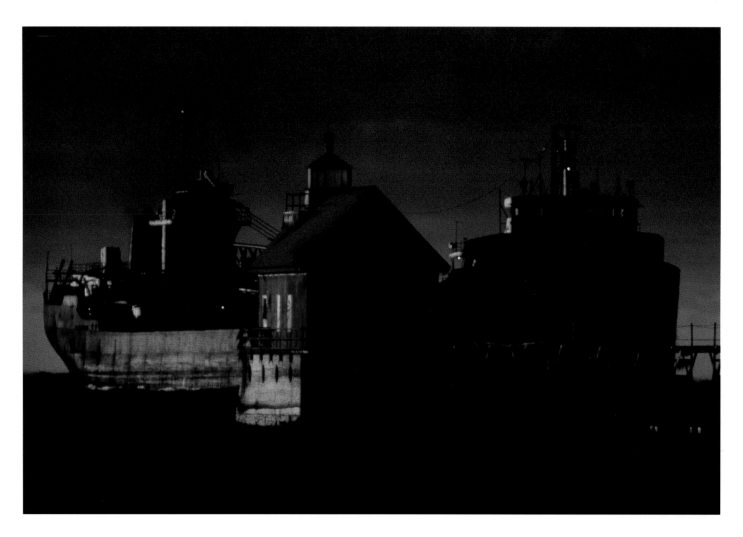

The *Herbert Jackson*, Grand Haven, Michigan.

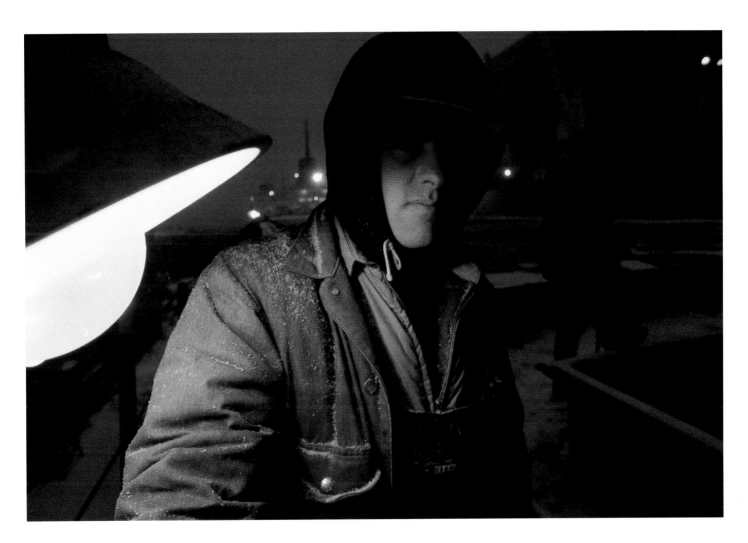

Grain handler, Port of Thunder Bay, Ontario.

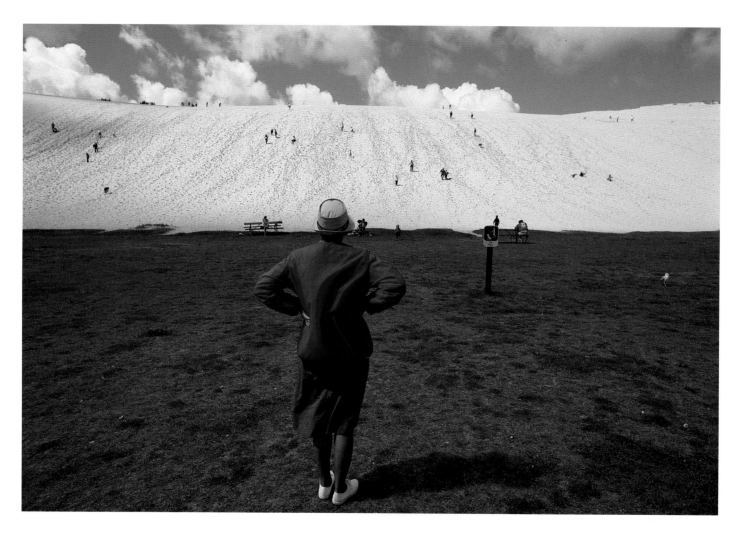

Sleeping Bear Dunes National Lakeshore, Lake Michigan.

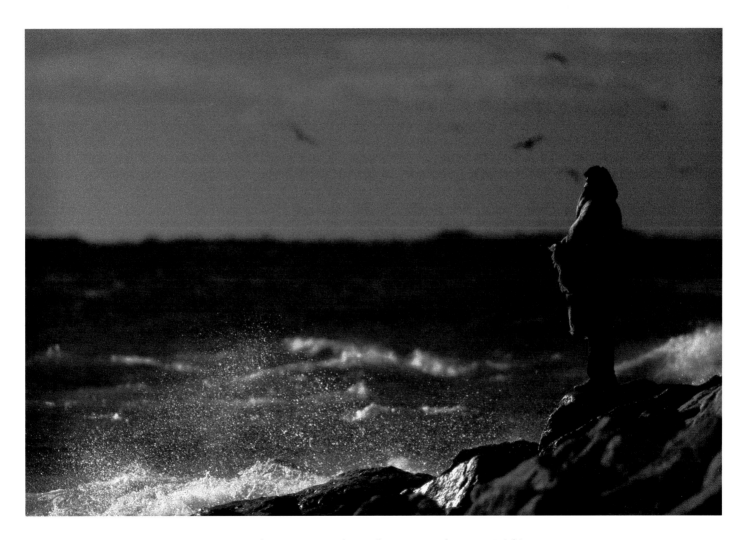

Navajo Indian viewing Lake Michigan, Grand Haven, Michigan.

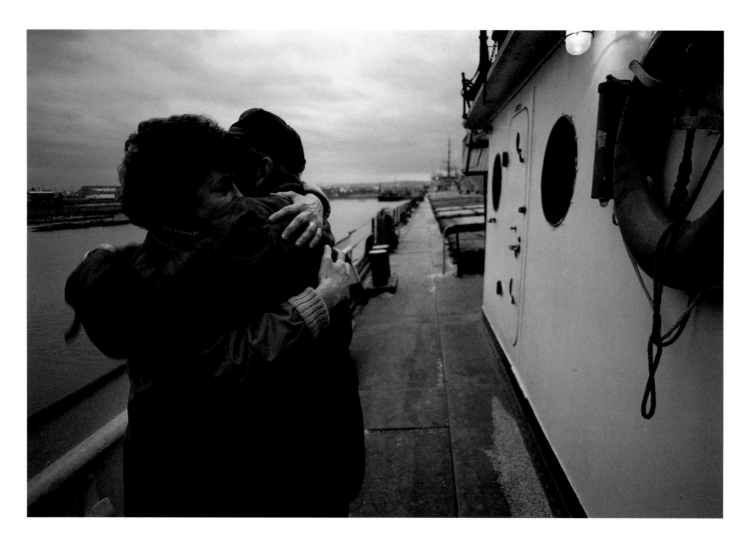

Retirement after 34 years of Great Lakes sailing, Duluth, Minnesota.

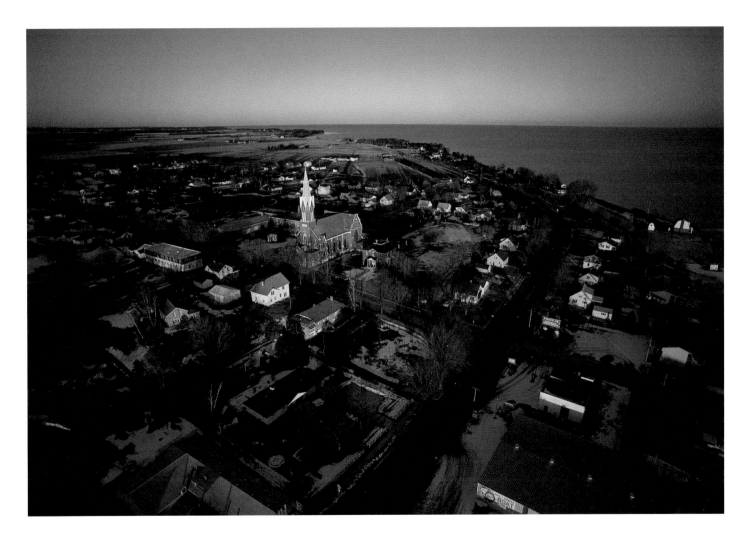

Algoma, Wisconsin, Lake Michigan.

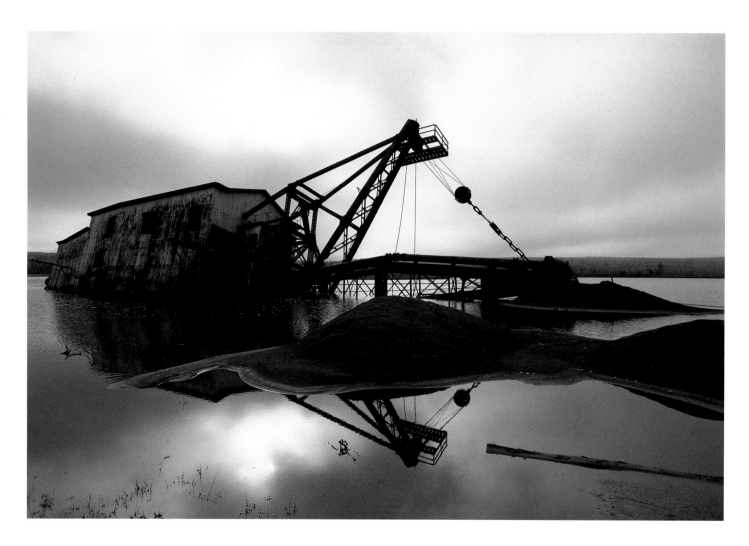

Old dredge, Torch Lake, Keweenaw Peninsula.

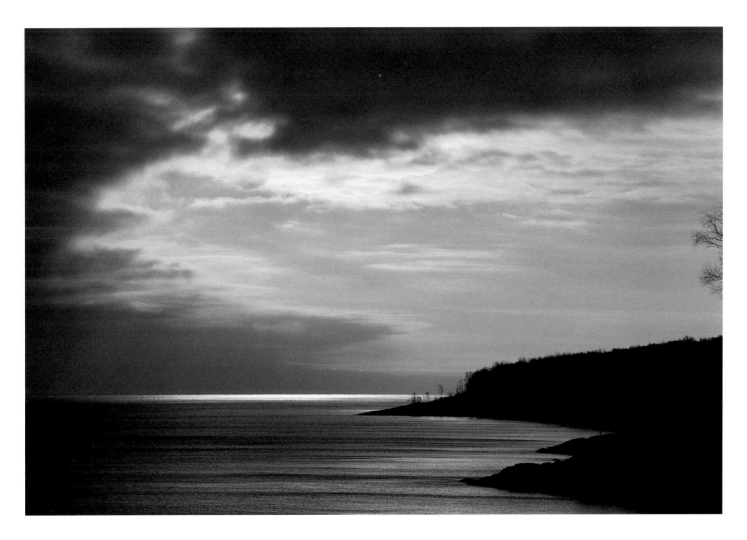

Autumn Clouds near Silver Cliff, Lake Superior.

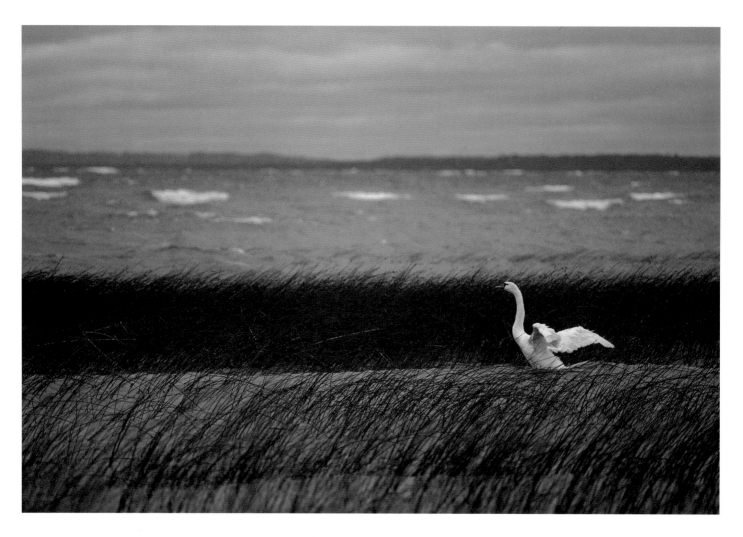

Waiting out the storm, Sturgeon Bay, Michigan.

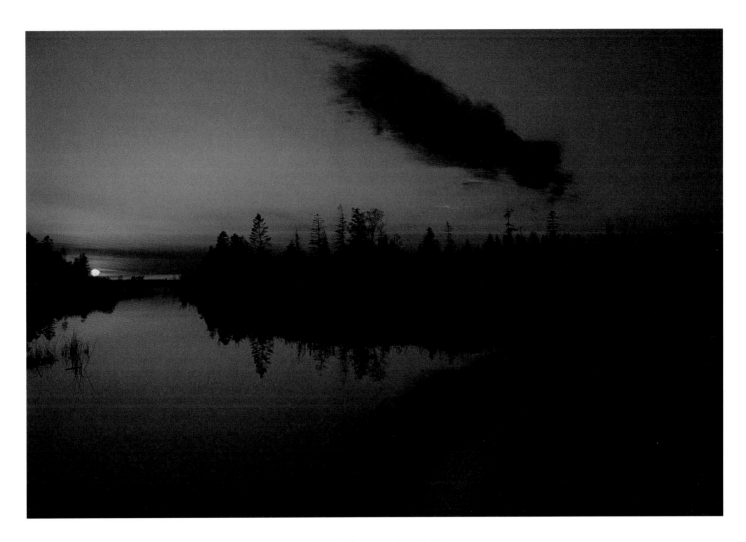

Northern shore, Lake Michigan.

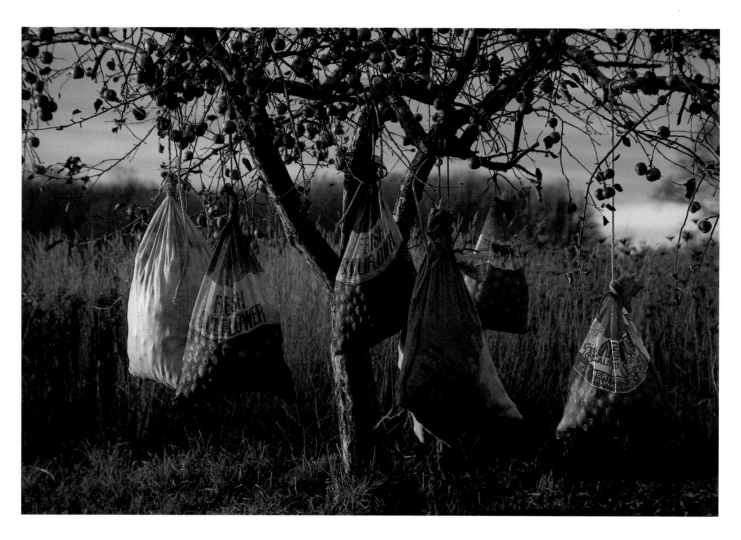

Apples saved for deer, Garden, Michigan.

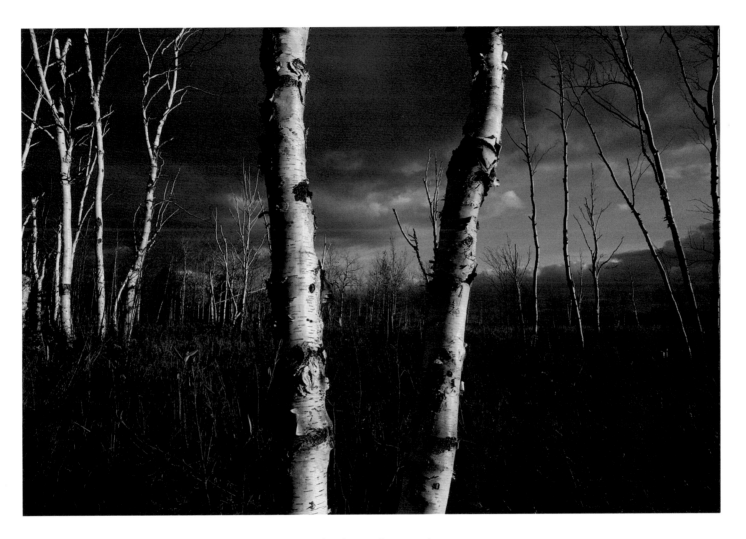

Paper birch, northern Michigan.

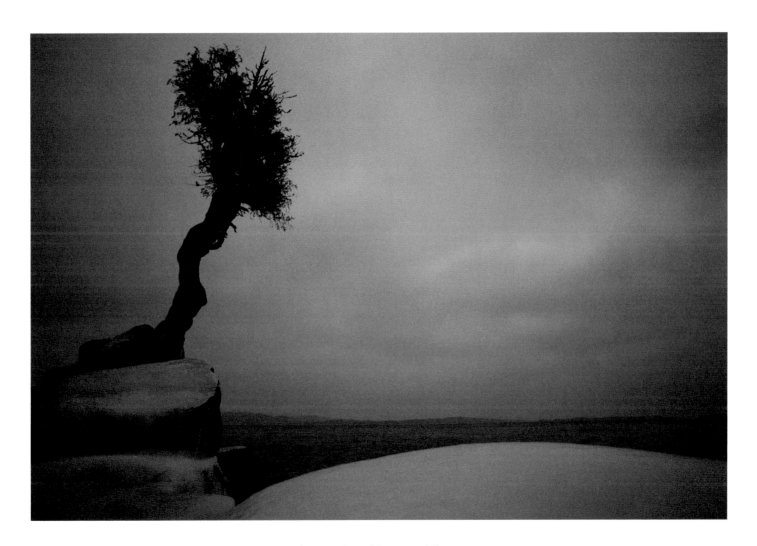

Witch Tree, Grand Portage, Minnesota

# About the Authors

Richard Olsenius is a 20-year veteran of newspaper and magazine photography and filmmaking. He has won numerous awards including the prestigious World Press Photo award. In 1987, Olsenius spent eight months on assignment for *National Geographic* Magazine covering the Great Lakes. Distant Shores is an outgrowth of that assignment, as is his video documentary - "America's Inland Coast," which aired on public television stations in 1989. Olsenius composed much of the music for the video, as well as the cassette tape of Distant Shores.

Christine Olsenius has 13 years of experience in water resource management and education. She has produced national programs, publications and films on water issues. She is currently vice president of Lake Superior Center, a non-profit organization formed to establish a freshwater public education center for the world's large lakes.

*Distant Shores* was designed by Rick Allen and Marian Lansky.

The typefaces used are ITC Serif Gothic, Adobe Garamond and ITC Novarese.

*Distant Shores* is printed on 100# Carolina Cover and Productolith Dull.